GLASGOW CENTRAL STATION

THROUGH TIME

Michael Meighan

AMBERLEY

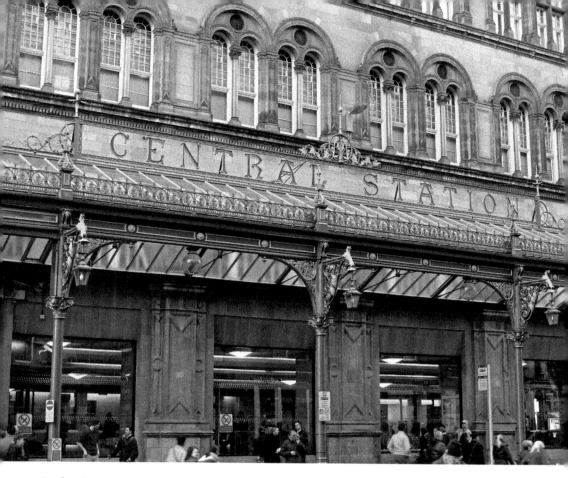

Gordon Street entrance.

First published 2013

Amberley Publishing
The Hill, Stroud
Gloucestershire, GL5 4EP

www.amberley-books.com

Copyright © Michael Meighan, 2013

The right of Michael Meighan to be identified as the
Author of this work has been asserted in accordance
with the Copyrights, Designs and Patents Act 1988.

ISBN 978 1 4456 1094 8

British Library Cataloguing in Publication Data.
A catalogue record for this book is available from
the British Library.

Typeset in 10pt on 13pt Celeste.
Typesetting by Amberley Publishing.
Printed in the UK.

Introduction

If you were to ask what my favourite spot in Glasgow was, I would tell you that the view from Lord Robert's statue at the top of Kelvingrove Park was second to none and has been since I was a wee boy living in Anderston. The next would have had equal status as a playground, for it would be to Central Station that I would go to experience the bustle of the station, collect engine numbers and, on one or two glorious occasions, even get a ride on the station shunters.

I would count myself a typical Glaswegian, certainly typical of my era, in that Central Station has played a major role in my life. Besides being a playground, it was at 'The Shell' within the station that girlfriends were met. It was the departure point for me and my family as we set off to Gourock or Wemyss Bay to catch a steamer 'doon the water' to Dunoon and Innellan.

Later on, with our Scout troop, I left Platform 1 on the London steam train, bound for Torquay and our summer camp. Still later, as a commuter to or from Edinburgh, I was to travel to and from the station and I can say that I never ever tired of rattling over the Clyde to enter one of Scotland's greatest buildings.

And it is also one of Glasgow's great streets, just as popular and as well-used as Sauchiehall Street and Argyle Street. Generations of Glaswegians have used it as a thoroughfare, at the same time taking in the hustle and bustle of this great station.

In all of the changes experienced by Glasgow, it has been a solid reminder of our industrial and commercial heritage. And it has reflected the rise and fall of the city's prosperity as well as its confidence. This great building has seen the rise and fall of Glasgow's industrial age and has grown with it. It has also seen the decline in our industries but has risen again in splendid glory, reflecting a new-found confidence in the people of Glasgow.

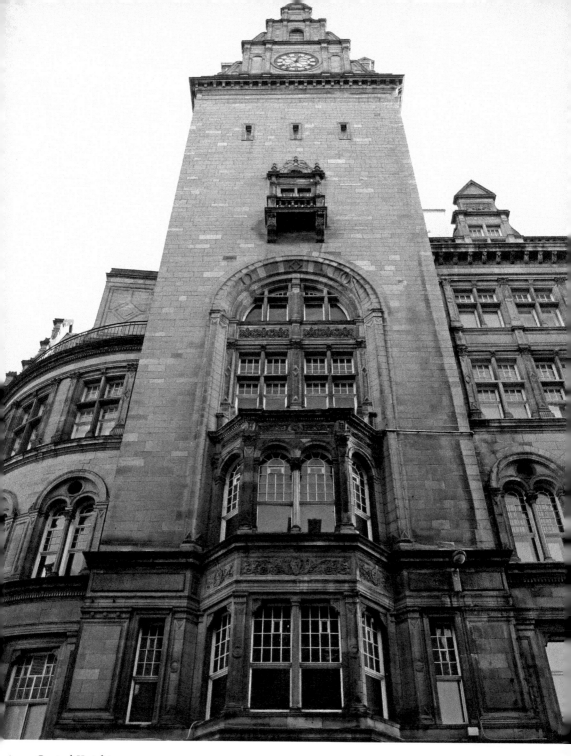

Central Hotel tower.

The City of Glasgow

Daniel Defoe, the author of *Robinson Crusoe*, visited Glasgow in 1707 and declared it, 'The cleanest and beautifullest, and best built city in Britain, London excepted.' By 1807 all this had changed. While there continued to be fine new developments, building in the city was generally uncontrolled, oblivious to sanitary engineering and was outstripping the ability of the fast growing population to be fed and watered.

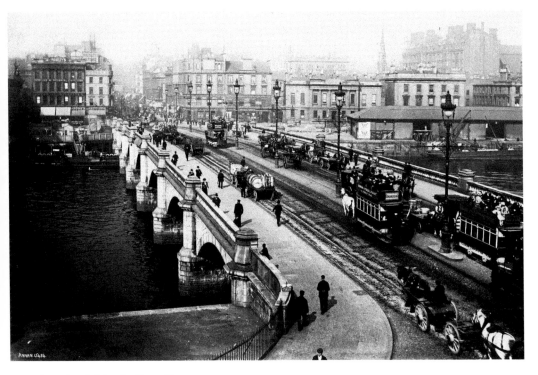

Jamaica Bridge in the 1880s
The railway bridge can just be seen near the top left of the photograph. While it is now called Jamaica Bridge because it is at the foot of Jamaica Street, it was sometime called Glasgow Bridge, Broomielaw Bridge or Telford's Bridge, having been designed by Thomas Telford. The building to the top right is the St Enoch's Hotel and station, opened in 1876.

The huge industrial expansion in Glasgow, aided and abetted by harsh conditions in the rural economy, was attracting migrants, mainly from Ireland, the West Highlands, and from Lanarkshire and Ayrshire. In 1750 the population was 32,000, rising to 200,000 by 1830 and on its way to a half million by 1870.

In these circumstances, disease was rampant and infant mortality high. The period also saw rises in crime, drunkenness and juvenile delinquency. It was a situation which, if left to continue, would probably see the city in economic decline and social disaster. This was a time for radical action.

This radical action came in the form of the 1866 City Improvement Act, which was a major programme to improve life in the squalid poorer areas of the city. The Act gave Glasgow Town Council powers to set up a City Improvement Trust. This was to purchase slum property and demolish it and to widen and re-align narrow city centre streets. The Act was also responsible for a new Cleansing Department. The areas targeted for slum clearance were mainly round about Glasgow Cross. The idea was to demolish the slums of the time, widen roads and then encourage private builders to build on the cleared areas.

However, building on the cleared land was very slow, partly because of the collapse of the City of Glasgow Bank as well as a recession at the time. At one time, the Improvement Trust had to cease demolishing properties and found itself Glasgow's biggest slum landlord. It wasn't till the 1890s that building got going again and by 1890s the Trust had build thirty-four tenements containing 1,200 homes. For example, Howard Street was built with sixteen single-room houses and thirty-two two-room apartments. By 1913 the Corporation, which took over responsibility for housing from the Trust, had built 2,199 tenement houses in the city.

At the same time, the commercial centre of Glasgow was expanding through the building of 'new towns' westwards from High Street. These are seen in the grid system of streets and squares such as Buchanan Street and Exchange Square. In this new Glasgow were the mansions, offices and churches of the ship owners and builders and the traders, the lawyers, insurers and bankers.

It was with this background that Glasgow Central Station came to what was then the west end of the city of Glasgow. The railways were originally built primarily for industry, for the haulage of coal and for other raw materials, as well as the finished product, for oil and for chemicals. At the beginning, railway companies had little interest in passengers, often confining them to open carriages or primitive coaches. But the cities were expanding. Although the Glasgow Improvement Act recognised the urban squalor and gave powers to do something about it, in the meantime those with the means were desperate to escape the filth and smoke of the city. Towns outside Glasgow and along the banks of the Clyde expanded to meet the demands for clean air as well as the growth of the population needed to fuel the huge rises in industrial production.

Before the railways, it was coaches or river and coastal steamers which met the need for travel to and from Glasgow. But the journeys were long and could be dangerous - the Clyde was a massive factory and along it were boats and ships moving in and out and across.

In the same way that modern trains are opening (or re-opening) access to towns and villages throughout Scotland, the railways were to bring the counties of Scotland closer as well as bringing London and the industrial parts of England ever nearer and nearer. With the coming of the First World War, they were to become an essential part of the war effort.

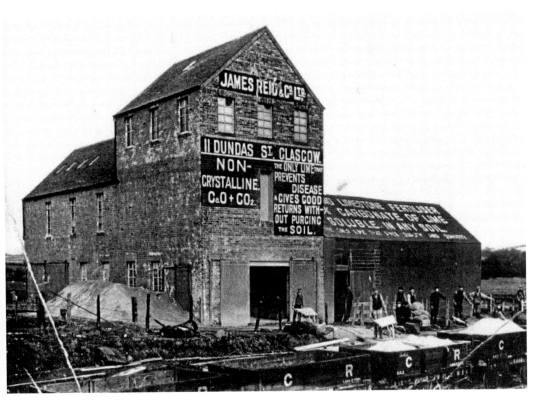

The railways were originally built primarily for industry. In this case, Glasgow merchant James Reid & Co. is moving agricultural lime on the Caledonian Railway.

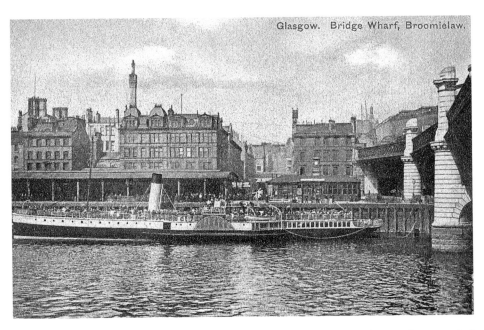

A paddle steamer bound down the Clyde from the Broomielaw. The newly expanded Central Station on the right.

They were also eventually to close down the busy Clyde steamer traffic as well as the coastal steamer trade. As the railways continued to spread their tentacles throughout Scotland, they enabled the growth of the city and this is reflected in the magnificent Central Station, Glasgow's Station.

It may seem strange but while Glasgow Central Station is now Glasgow's main railway terminal, it was not always so. Until the Central and St Enoch were opened, Glasgow's main terminal for southbound trains was at Bridge Street, on the other side of the river.

Bridge Street Station had been the terminal of the Glasgow & Paisley Joint Railway and opened for traffic in 1840, quickly becoming popular, particularly for those passengers used to the much longer steamer journeys from the Broomielaw down the River Clyde and along the west coast to Ayr and beyond.

While we are familiar today with the plethora of different operating companies, it was much the same in the early days, before the grouping of railways under the Railways Act of 1921 and eventual nationalisation under the Transport Act of 1947.

Bridge Street station had been jointly managed by the Glasgow, Paisley, Kilmarnock & Ayrshire (GPK&AR) and the Glasgow, Paisley & Greenock (GP&G) railway companies.

The GPK&AR merged with the Glasgow, Dumfries & Carlisle Railway to form the Glasgow & South Western Railway (G&SWR) in 1850. This became part of the London, Midland & Scottish Railway Company in 1923.

The GP&G became part of the Caledonian Railway in 1847, which in turn would also become part of LMS in 1923.

For thirty years the station served both the Caledonian Railway and the Glasgow & South Western Railway well. However, both companies wanted to get across the river, into the heart of the city.

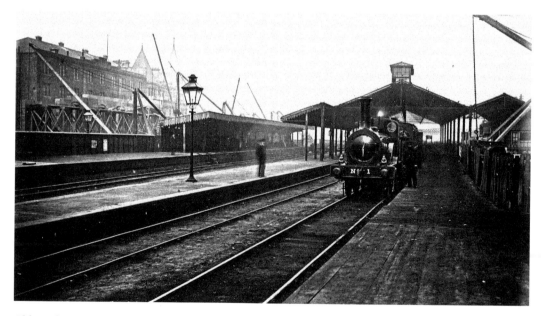

Old Bridge Street Station, serving both the Glasgow & South Western and the Caledonian railways.

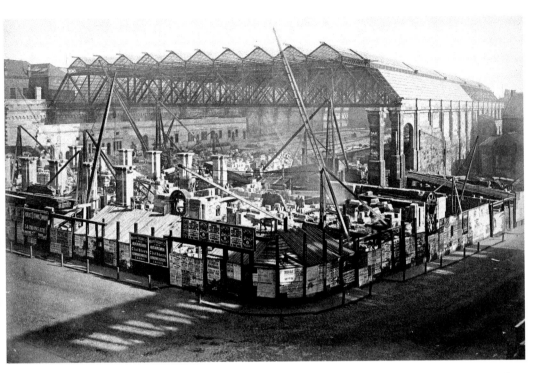

The New Bridge Street Station under construction. This was built following a serious accident at Bridge Street in 1873. The collision had been put down to congestion on the lines. The traffic had 'outgrown the capabilities of the station' according to the Board of Trade.

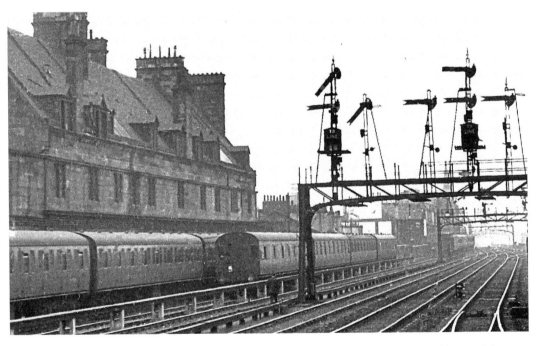

Looking forward from Central Station in about 1950, with the remaining buildings of the new Bridge Street Station on the left. There used to be platforms where the sidings are now.

Former Bridge Street Station buildings. This was a newer building and the original buildings were to the right of this, nearer the river, on the other side of Kingston Street, which can be seen on the far right.

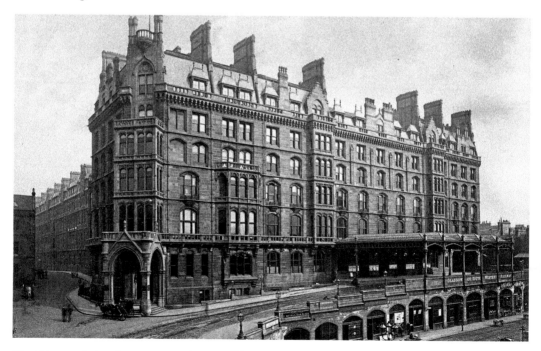

The Glasgow & South Western Railway Company's St Enoch Station and Hotel.

Crossing the river was never going to be easy, even in entrepreneurial Victorian times when coal and the railways reigned supreme. While Bridge Street Station was on the south bank of the river, the Clyde was a major obstacle. The Clyde Navigation Trust objected to the possible crossing – while that end of the Clyde may be quiet now, at that time it was a bustling thoroughfare, and crossing it would have restricted trade up and down the river.

In 1870, it was the Glasgow & South Western which was to be first over the river on the existing bridge, but not to St Enoch, their eventual terminus. Given the difficulties they had in securing properties on the north bank, they decided to build a temporary station in Dunlop Street. This was used from 1870 until 1876, closing on the day that St Enoch's Station opened. The hotel was to open three years later. The hotel had actually been built by the City of Glasgow Union Railway but was acquired in 1883 by the Glasgow & South Western.

St Enoch's was the city's largest hotel, with 200 rooms, and with the station was the first building in Glasgow to be lit by electricity. St Enoch's Station suffered the same fate as many other routes and stations under Dr Beeching's railway rationalisation programme and closed in 1966. The hotel limped on for a number of years, but times and poor fire precautions caused its closure by British Railways in 1977, in the face of protest from Glaswegians. It was demolished. It was after all an amazing building and a favourite in the city.

The imposing station clock which looked over the St Enoch concourse was saved for the nation and now graces Cumbernauld town centre. It briefly appeared as a backdrop in a scene in *Gregory's Girl* which was shot in Cumbernauld.

Glasgow Central Station

You would have thought it sensible for the two 'operating companies' to collaborate on both a crossing and a terminal, but it was not to be. There had been a certain amount of acrimony in jointly operating Bridge Street and this carried on. The 'Caley' thought that the G&SWR wanted too much for use of the station so they decided to build their own, with plans drawn up in 1866 for a station at Gordon Street in the heart of the city.

But it was not until August 1879 that trains finally departed the platforms at Gordon Street, which was to become Central Station. This was after the completion of the station buildings and the construction of the bridge over the Clyde designed by Blyth & Cunningham and built by Sir William Arrol.

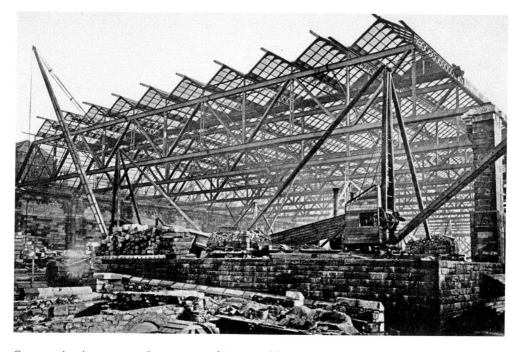

Construction in progress. Steam cranes being used but not apparently in steam.

After only a few years, the demands on the station were greater than expected. By widening the station and installing a ninth platform, a temporary solution was found. It was only temporary in that shortly afterwards the station was again congested. The demand for passenger traffic was booming and more dramatic measures were needed.

From 1899 to 1905 the station was substantially extended to give 13 platforms. The new work was designed by architect J. Miller and engineer Donald Mathieson, with the steelwork being erected by the Motherwell Bridge & Engineering Co. This resulted in the familiar façade in Hope Street along with new platforms extending over Argyle Street, served by an additional bridge over the Clyde. At the same time, the Central Hotel was extended and a new office block, designed by J. Miller, was built in Union Street.

With the redeveloped Central Station, it was felt that there was no need for Bridge Street Station and it closed in 1905.

From then, Glasgow Central Station remained mostly unaltered until its part renovation in the 1980s. The ticket office moved to a new Travel Centre next to the Gordon Street entrance and a new electro-mechanical destination board appeared above the platform entrances. The building hosting the destination boards and booking offices became shops, with a bar and restaurant upstairs. The floor was covered with terrazzo tiles.

A new five-year renovation programme started in 1998 with the biggest alteration to date. The station was completely re-roofed and the building cleaned. The remarkable differences are seen in these photographs. Around 2005, a new LED destination board appeared. Further platform improvements are ongoing and automatic ticket barriers have been installed on most platforms.

The regeneration work on the station earned the prestigious Europa Nostra European Cultural Heritage Award for its architects, Gordon Murray and Alan Dunlop, and builders Arup Scotland: 'Awarded for the research and exemplary conservation of an important nineteenth century train station, including important protection measures to the roof, executed with sensitivity and meticulous attention to detail.'

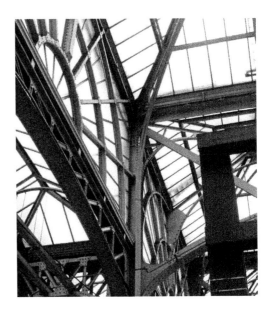

Roof trusses.

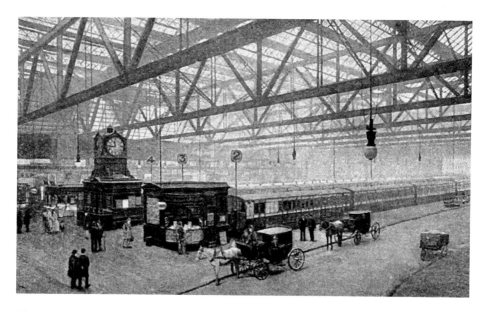

Glasgow Central Station in 1894, before the extension. The platforms were originally numbered upwards from right to left but by 1907 this had changed, with platform 1 now on the left. The construction of the roof can clearly be seen. Horizontal beams support the glass roof. The roof glazing was carried out by one of Scotland's longest lasting companies, the Pennycook Patent Glazing & Engineering Company, which was incorporated in 1880 and finally closed in 2002. They had developed a glazing system free of putty which was used in many British and European buildings, including the Imperial War Museum in London and the Rijksmuseum in Amsterdam.

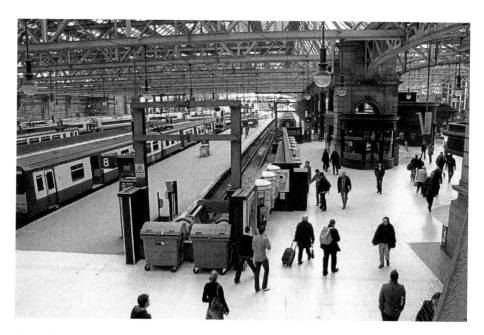

Central Station now. The extension is on the right and shows the use of arched supports rather than horizontal beams. The modern lights are remarkably similar to the original.

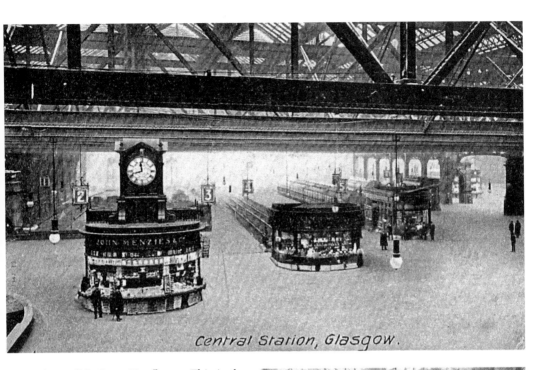

Central Station, Glasgow.

Above: 'My Dear Mayflower. This is the depot I arrived at first to get the train to come to grandpa. Love to all from your loving Mama.' This was posted in Glasgow on 16 May 1907 and took only 10 days to be received in Massachusetts on 26 May. It shows the station concourse soon after the 1905 redevelopment.

Right: John Menzies Bookstall, Glasgow Central Station.

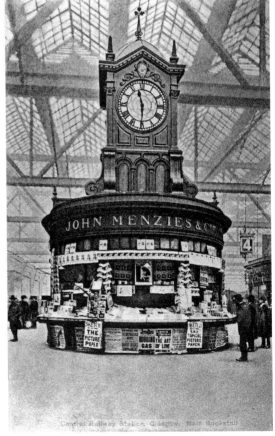

Central Railway Station, Glasgow. Main Bookstall

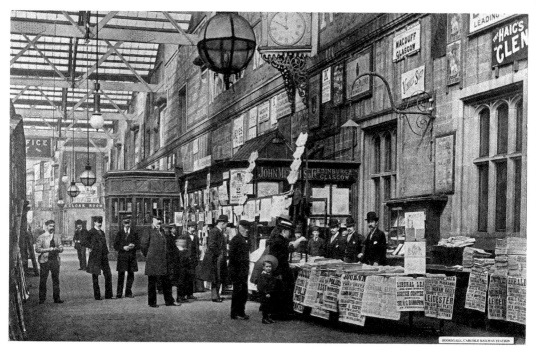

John Menzies

John Menzies was an institution in Scottish stations and high streets, seen here in Carlisle and in Stirling below. Menzies, established in 1833, is still based in Edinburgh. Menzies sold its shops to WH Smith in 1998 to concentrate on newspaper distribution and aviation services.

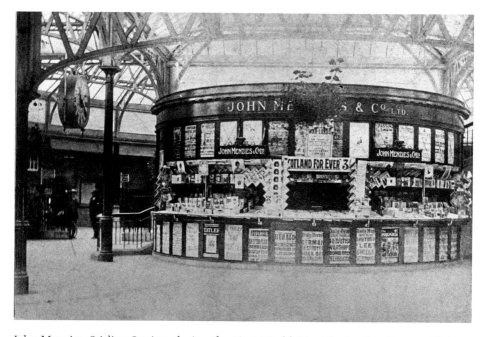

John Menzies, Stirling Station, during the First World War. The bookstalls are still there but no longer used as shops.

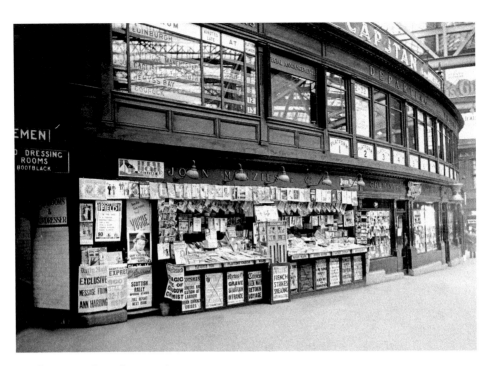

Kiosks, Central Station, 1936
Below the departure boards again is John Menzies and, amazingly, Boots the Chemist, which is back in its original place after 80 years. The entrance to the underground gentlemen's lavatories is on the left.

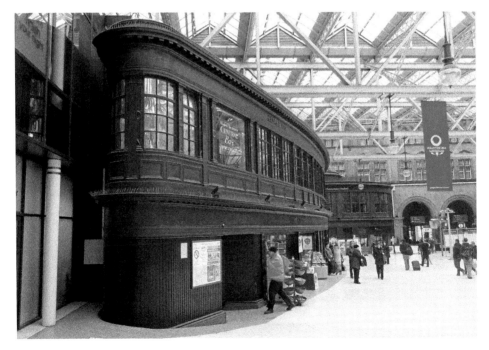

The same building, now used as shops and a bar. The roadway has been removed to provide additional shop space.

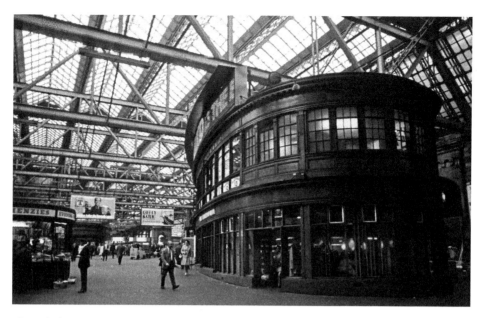

The Caledonia Lounge, 1970. Having been a lounge bar then a ticket office, the underneath is now a branch of Marks & Spencer and upstairs, where there was once the destination boards, is now the Central Bar. The distinctive curved wooden buildings were designed and installed between 1899 and 1905 under the direction of Engineer-in-Chief Donald Matheson, who believed that curved buildings and rounded corners helped prevent crowding and bottlenecks. As far as I can remember, there was also an entrance from under the Hielenman's Umbrella, with the same curves to the ticket office and staircase rising up and round to the station.

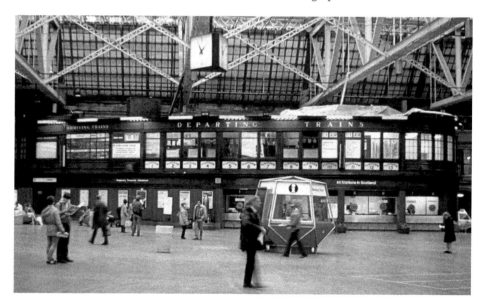

By December 1984 the Caledonian lounge had moved, with a ticket office taking its original place. An incongruous, futuristic information kiosk is in the middle. And right in the middle against the wall is the famous commemorative shell which has acted as long as I can remember as a meeting place: 'See you at the shell.' You might see the shell in various places in this book and it is now beside the main Gordon Street entrance.

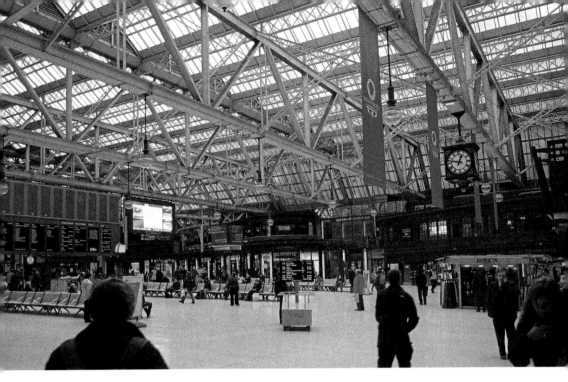

The modern station concourse.

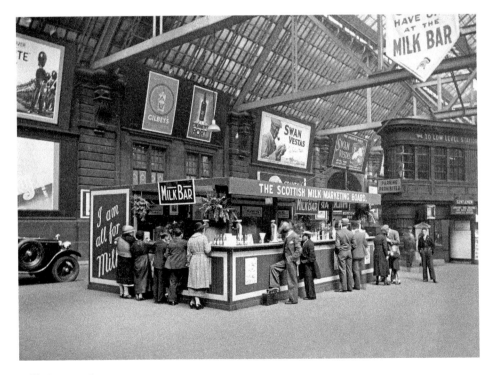

Milk Bar, 1936
This was the Scottish Milk Marketing Board, set up in 1934. Presumably a marketing idea.

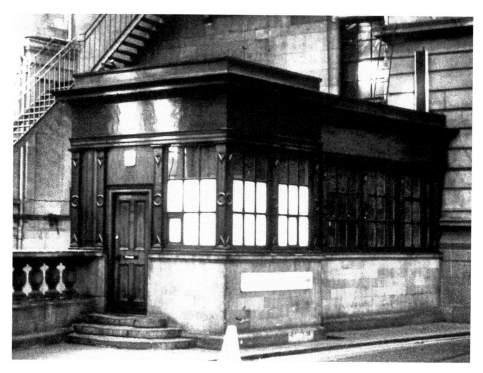

Former taxi office, 1979.

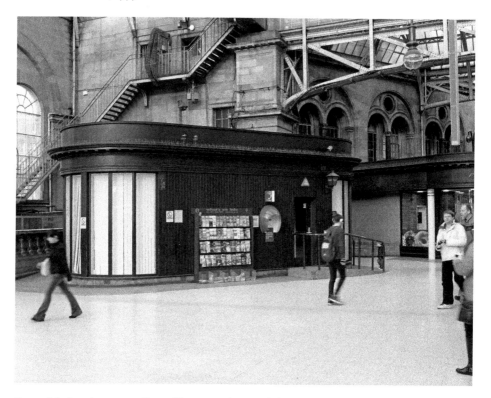

Remodeled and now a police office, complete with blue lamp.

The original carriageway entrance from Hope Street, through an amazing hairpin bend which turns back under this entrance.

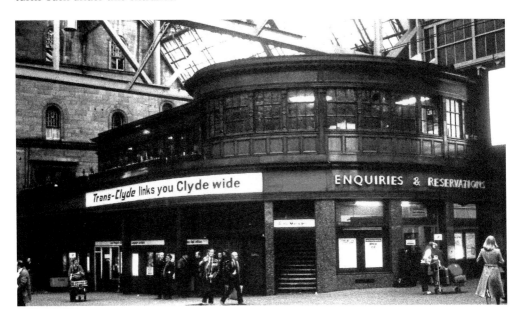

The enquiries and reservations desk in November 1979, with station offices above.

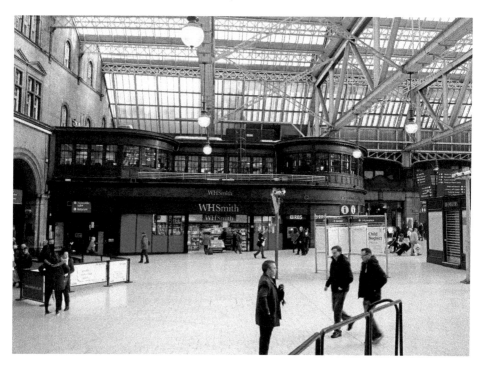

By 2011 the wooden building has been tastefully altered and houses WH Smith, with offices still above.

Concourse, 1979

In the middle you can again see the 15-inch First World War howitzer shell made by William Beardmore & Co. It was made into a charity collecting box and became a famous meeting place for many years. It now stands at the Gordon Street entrance. This picture shows just how dark the windows were.

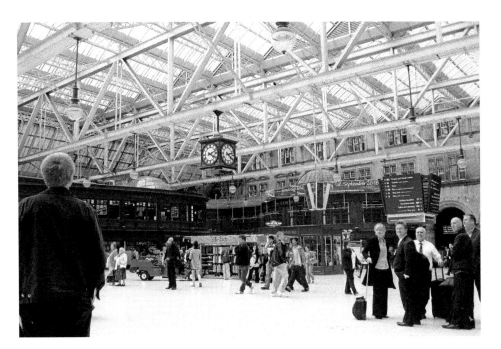

Concourse, 2010

This photo looks towards the rear entrance of the soon to be re-opened Grand Central Hotel. This shows the dramatic changes to the roof. The concourse is altogether cleaner and more welcoming while still retaining the splendour of the curved wood. The classic clock with Roman numerals has been re-instated.

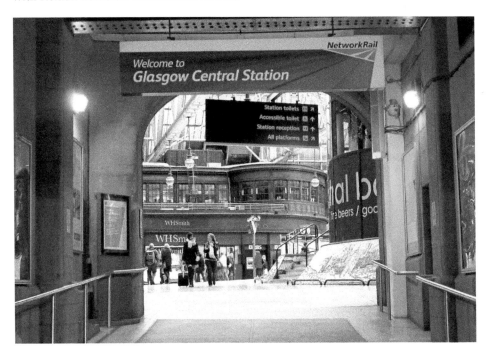

The existing Hope Street entrance, which once combined vehicles, mostly taxis, and pedestrians.

November 1979
Looking towards the platforms with the John Menzies stall now on the right. The machine on the wall issued platform tickets. This arch marks the original Hope Street side of the station before the extension was built.

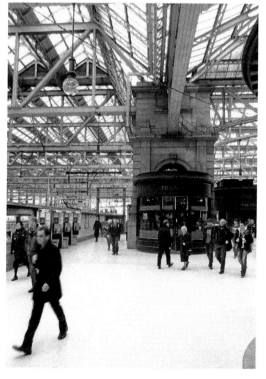

Good use has been made of the arch by incorporating a coffee bar. The newer part of the station on the right shows the different roof structure.

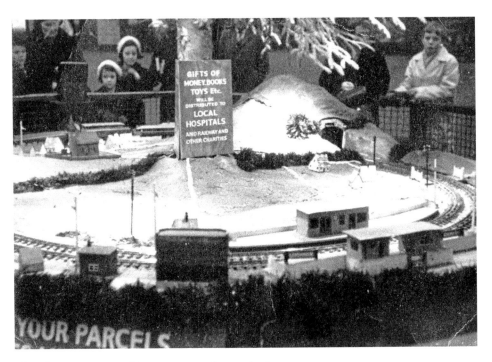

The Christmas tree – this was a must for me in the 1950s.

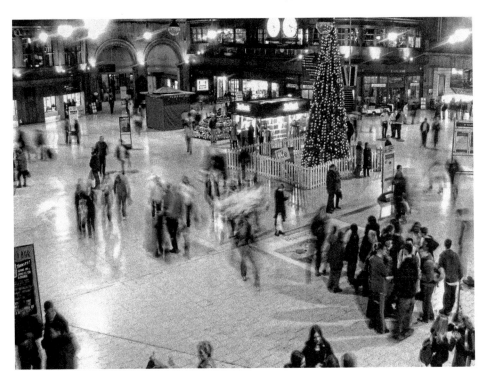

Rush hour with Christmas Tree, 2009
Christmas, but the main attraction has gone. I loved the Hornby railway set. Still, it is now a very attractive setting.

Refreshment rooms at Glasgow Central, above in 1936 and below in 2012.

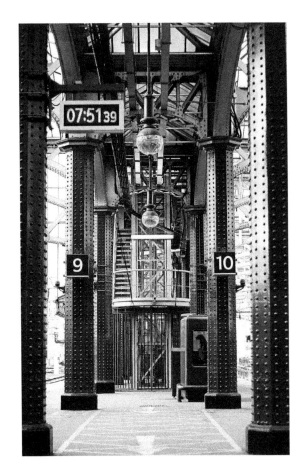

Right: Azam Khan's marvellous study of the central supporting columns on platform 9/10.

Below: Thistles.

The Union Street entrance.

The Gordon Street entrance.

The Station and its Surroundings

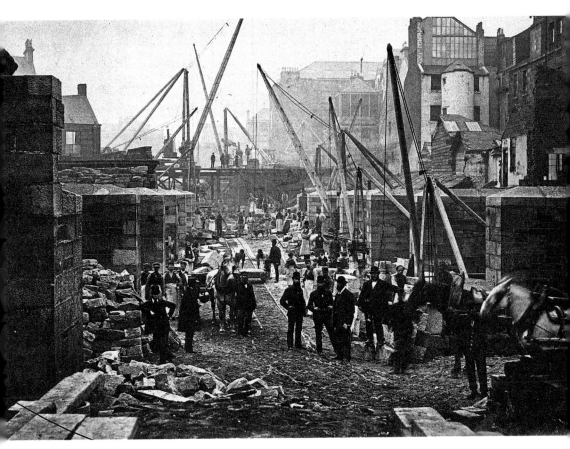

Progress from the Broomielaw northwards. It looks as if the construction work is progressing quite neatly through the existing buildings on Oswald Street and Jamaica Street, even to the extent of cutting through walls and buildings rather than demolishing them. Several seem to have been cut through and boarded up. The tenements to the left may be in Wood Lane, which was demolished to make way for the new bridge.

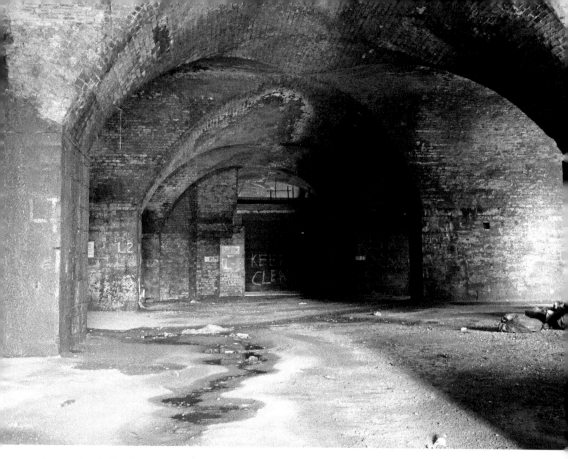

It may be difficult to imagine but this is exactly the spot. The arches are used for a number of purposes and these have most recently been used for parking. You can see how the stone columns in the top image are bevelled so that the arched brickwork can sit upon them. Cobbles can still be seen in patches under the accumulated debris.

Argyle Street

The huge industrial expansion in Glasgow aided and abetted by harsh conditions in the rural economy was attracting migrants, mainly from Ireland, the West Highlands and from Lanarkshire and Ayrshire. In 1750 the population was 32,000 rising to 200,000 by 1830 and on its way to a half million by 1870.

This influx of new Glaswegians dispersed throughout the city to work in the factories, the mills, the chemical works and in service. In the way of immigrants, they met together where they could. A popular place for the Highlander was at the Central Station bridge over Argyle Street. This was to become known as 'The Hielenman's Umbrella'.

Hielanmen possibly met there after their church services as St Columba's Church of Scotland, 'The Highland Cathedral', dating back to 1770, backed onto Central Station until the station expansion, when it closed. With the proceeds of the sale to the Caledonian, a lovely new church in red sandstone was built in St Vincent Street, where it still stands and still provides services in Gaelic to the church community.

An iconic image: a Coronation tram exits The Hielenman's Umbrella, heading west along Argyle Street. In June 1960, the street still has granite setts.

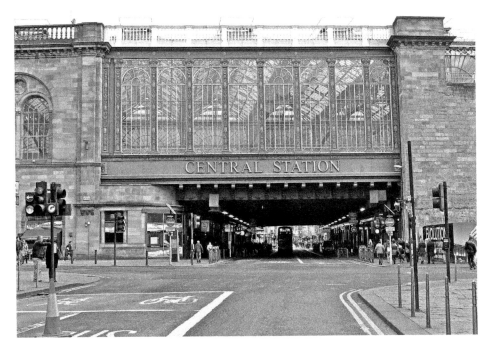

The Hielenman's Umbrella, July 2012
A dramatic difference; the image shows the effect of the clean-up of the station, making it even more imposing and elegant. Underneath, it is just as dark and still iconic, but not a Hielenman in sight.

There was also, in Gordon Street, the Hope Street Gaelic Chapel, built to cater for the rising numbers of Gaelic speakers from the Highlands flooding into the city. So it easy to see how they may naturally have gravitated to the crossroads of Hope Street and Argyle Street to meet.

The Caledonian Railway and the Glasgow & South West Railway companies both had difficulties in getting over the river and it wasn't just the Clyde Trustees, the city council and the Admiralty that were in the way. By the time Central and St Enoch stations had been planned, both sides of the river were fairly commercialised. It was just here that Glasgow's industrial growth had started. What had been individual villages along the river had merged and grown into a riverfront area of factories, mills, tenements, warehouses, foundries, lodging houses and hotels for the arriving and departing travellers.

Anderston was the original home of what was to become Walter McFarlane's great Saracen Foundry, as well as of James and George Thomson's first shipyard. Founded in 1847, this was called the Clyde Bank Foundry and this name was taken with the company, run by sons, to Dalmuir further down the river. The shipyard, its workers' houses and the town which sprung up round it was to become one of Scotland's first new towns – Clydebank. John Brown & Co., a steel company from Sheffield, bought the firm in 1899 and so was established the engineering giant and town that has become synonymous with Clyde shipbuilding.

Finnieston was the home of the Hyde Park Foundry, later moved to Springburn to become the home of North British Locomotives. Govan was to become the home of many shipyards and is still building ships at BAE Systems.

The new railway tracks, stations and buildings were not then being built on farm and field, for the city was well established and building the railway infrastructure involved the demolition of many buildings, some of them substantial and only recently built.

The village of Grahamston was almost completely obliterated. I have to say that growing up in Anderston I had no knowledge of Grahamston, even though I lived a few streets away, it being between my house in Anderston and the Central Station.

Like Anderston, Finnieston, Blythswood, and Kinning Park, Grahamston had been a village, just outside what was then the western boundary of Glasgow. It was named after John Graham of Dougalston, an advocate, who feued around 6 acres from the Blythswood Holm in 1709 and who modestly gave it his own name.

Grahamston lay in the square of land bounded roughly by Mitchell Street, Hope Street, Argyle Street and Gordon Street. In common with the other villages of Glasgow, it succumbed to the growth of industry and commerce. By the 1850s what had originally been fields and market gardens had been built upon and Grahamston had formally been absorbed into Glasgow.

The area included a church, woodyards, a sugar refinery, a gas holder and a brewery as well as tenements. The main street in this small area was Alston Street, named after Glasgow merchant John Alston. Besides private houses, Alston Street, over the time of its existence, hosted a theatre, building contractors and crystal chandelier makers.

With the inexorable march of progress and Victorian endeavour, most of Grahamston was to disappear under the tracks and platforms of Glasgow Central Station. But out of that grew a myth, and nothing more, that some vestiges of Grahamston still exist in tunnels under the station, even to the extent that shops were left, still with articles on the counters,

as well as cobbled streets. This is nonsense of course, as the area was completely cleared in order to put down the massive foundations into what is a gravel and sand sub-soil. It's a nice idea though and one I often gave thought to when I explored the station when I was young, looking for the secret entrances. I never had the courage, though, to enter the massive network of service tunnels which do lie beneath the station. The cobbled street idea may have come from the fact that the arches in Midland Street and Broomielaw, below the southern end of the station, have been used for storage and parking for many years and were in fact cobbled – some still are.

The plans for the Central Station emerged at the time that the City of Glasgow had been undergoing an unprecedented redesign and re-building. From the 1780s, a development plan was implemented to which builders and architects were expected to comply. While not to the same exacting designs of the Edinburgh New Town, nevertheless the city was being squared off with buildings and streets set out in a grid system. This can be seen clearly in Blythswood Square, Exchange Square and Buchanan Street. Behind the commercialisation of the riverfront, Glasgow was extending beyond the old centre of the city, westwards and eastwards. Many of the buildings that we now know in the commercial centre of the city were townhouses built for the new commercial directors and managers and can still be seen in Bath Street and St Vincent Street and around Blythswood Square. It was within this grid structure that Glasgow Central Station fitted, surprisingly neatly given its size.

What is now in sight though, on the columns supporting the great glass walls, are both the emblems of the Caledonian Railway Company as well as faces which are probably those of Sir James Thompson, Chairman of the Caledonian Railway between 1901 and 1906. The emblem of the Caledonian Railway Company was the Lion Rampant surrounded by a garter.

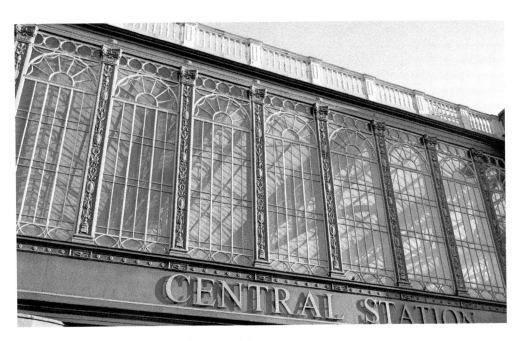
A segment of the bridge with emblems and faces.

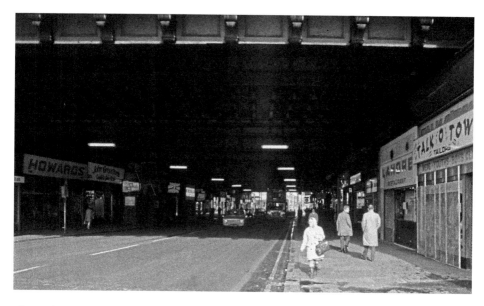

The Hielenman's Umbrella, 1970. I think the second neon-signed shop on the left-hand side was called 'Glasgow's Electric Lighthouse' and sold electrical equipment. I may be wrong about the name. We have lost many of these quirky wee shops. I remember being in the Lahore 'Indian' restaurant, which was one of the first in Scotland, I think. Next to that was a licensed grocer, and I clearly remember asking my father what the advert for OVD meant – Old Vatted Demerara (rum). John Greenlees ran a shoe shop opposite.

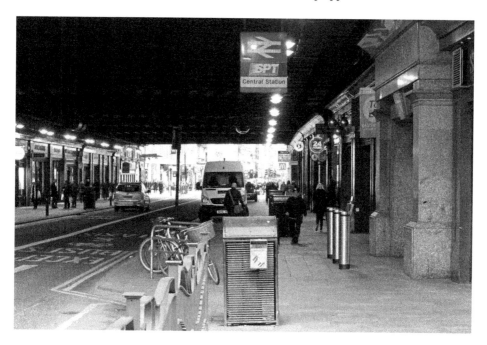

There is now an entrance to the station on this side. No household stores remain here, but there are fast food and fast clothes shops instead. There is now an entrance to The Arches venue, which has made good use of the old vaults. I can still give evidence of the pervading smell of the greasy spoon which has long been a feature of the Umbrella.

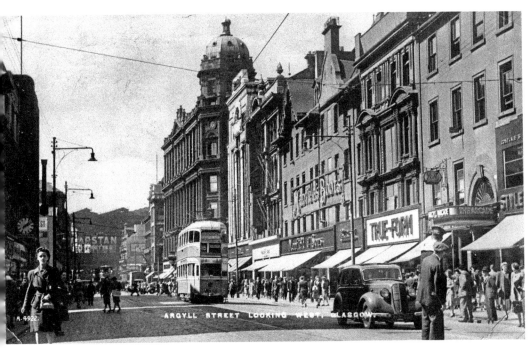

This view, posted September 1950, shows a very busy Argyle Street looking west towards the Central Station. The Argyle Arcade is on the right.

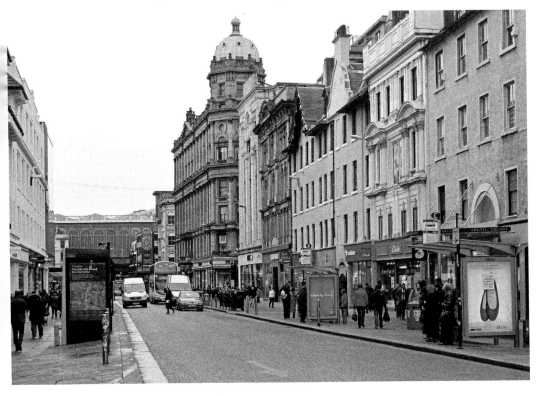

Argyle Street more than 60 years later.

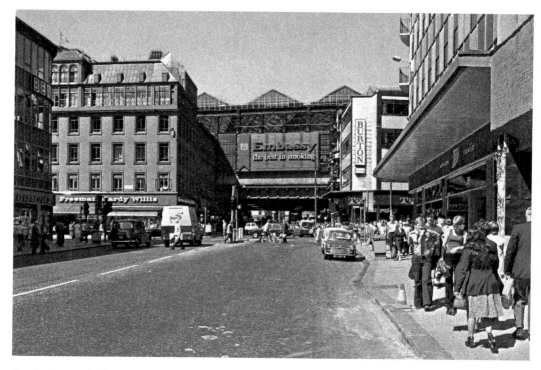

Boot's Corner, looking towards the Hielenman's Umbrella. The corner was a meeting place in the days before mobile phones. Many a young Glaswegian has been stood up there and I have to count myself among that number.

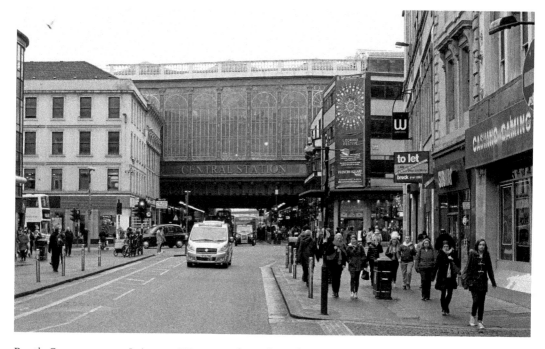

Boot's Corner as was. It is now Waterstone's. Tailors, department stores and shoe shops have given way to fast food, but it is still as bustling, still as noisy.

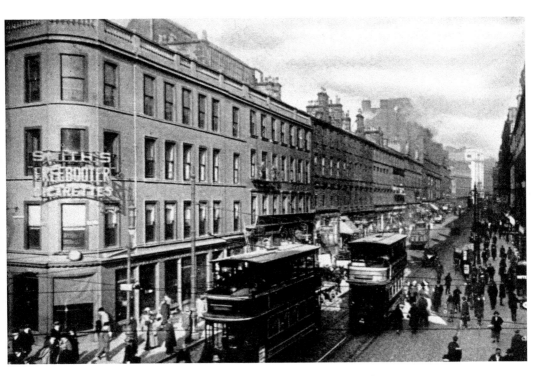

In this view looking up Union Street, tram cars are much in evidence.

Union Street

The sign on the corner on the left is for Smith's Freebooter Cigarettes. Stephen Mitchell is probably one of the best known of a few Scottish tobacco merchants who were to expand their businesses, moving from the low-tech manufacture of pipe tobacco to highly mechanised cigarette manufacturing using modern machinery. Their companies were eventually to be consumed by growing conglomerates and, like other manufacturing enterprises, lost to Scotland.

Stephen Mitchell was not a well publicised man so very little is known about him and his lonely death from a fall in the retirement town of Moffat. Mitchell had been born in Linlithgow in 1789, where his family had been involved in the tobacco business. In 1825 import legislation requiring the use of bonded warehouses in designated ports had taken his company to a base in Candleriggs, and then to St Andrew's Square in Glasgow's Gallowgate area.

The company continued to flourish, being taken over by his brother and then his nephew, also Stephen. Stephen remained unmarried and retired to Floral Cottage in the spa town of Moffat. Unfortunately, he was found dead with head injuries, presumably through a fall on a walk to a local mineral well. He left an astonishing legacy, for not only had he made money from cigarette manufacture but he had also invested in railways in Britain and in North America. His will provided bequests to charitable organisations and to the Unitarian Church in Glasgow. The largest, however, was the huge gift of £70,000 for the endowment of a large public library. This was gratefully accepted by the City Council and so was established

the Mitchell Library, one of Scotland's greatest public institutions which provides lasting benefits to the city.

Mitchell's other legacy was, of course, the establishment of a cigarette manufacturing industry which combined with W. D. & H. O. Wills and others in 1901 to become the Imperial Tobacco Company.

Stephen Mitchell represented a tradition of tobacco trading and manufacturing in Scotland which had started with the 'Tobacco Lords' of the eighteenth century who made fortunes in the trade between the New World and Great Britain and who are still remembered in thoroughfares in Glasgow's Merchant City such as Virginia, Glassford, Jamaica, Dunlop and Buchanan streets.

The Caledonian Chambers were designed by Glaswegian architect James Miller for the Caledonian Railway Company and completed in 1905. James Miller also designed the iconic Wemyss Bay railway station and the St Enoch Underground station. They were subsequently occupied by British Railways and now by First Scotrail.

James Miller is one of Scotland's unsung architects and designed a number of iconic

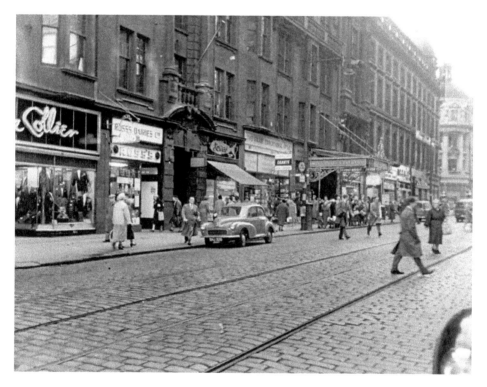

The Caledonian Chambers, c. 1950
The Caledonian Chambers, with the Central Station entrance clearly visible across Union Street, which still has its tram lines and cobbles. Ross's Dairies were a Glasgow institution, as was Grant's Educational Co. Ltd, which was a bookseller and stationer. Sawer's fish shop, with the awning, was to go on to become MacFisheries. On the left, John Collier, 'The Fifty Shilling Tailor', was a chain of menswear stores which sold the 'Saturday Night Suit', a budget suit allowing young Glasgow men to emulate the pop stars of the early 1960s. An early TV jingle was: 'John Collier, John Collier, the window to watch.'

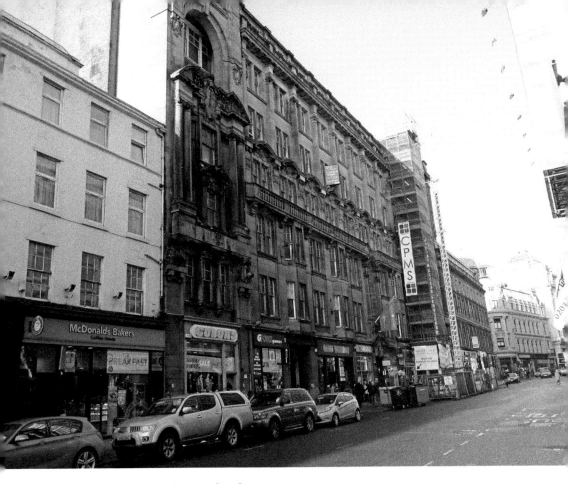

Union Street and the Caledonian Chambers, seen in 2013.

buildings in Glasgow and elsewhere in Scotland. Born in Perthshire, he went to school in Perth, where he undertook an apprenticeship with Andrew Heiton, later working with Hippolyte Blanc in Edinburgh. Blanc is best remembered in Scotland for his Gothic Revival style such as the magnificent Christ Church in Morningside in Edinburgh.

Miller joined the Caledonian Railway as an architect in 1888 and began designing railway stations. In 1892 he struck out on his own but retained contacts with the Caledonian Railway. Working from his offices in West George Street, he continued to work for the Caley but also did work for other railway companies. He died in 1940.

Besides the Caledonian Chambers, he is remembered for the Turnberry Hotel and Clydebank Town Hall. And for those familiar with the West Highland Line, the standard station designs are his – he worked on these with engineer Charles Forman.

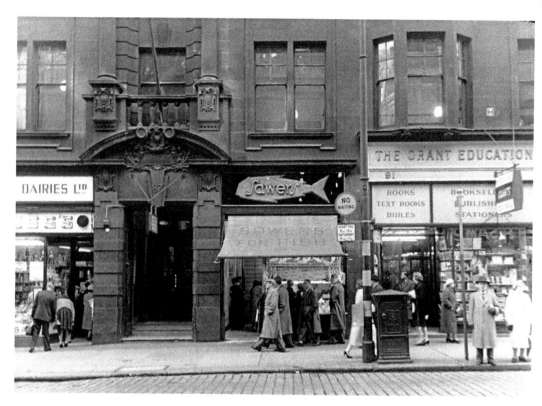

The Caledonian Chambers, Union Street, Glasgow.

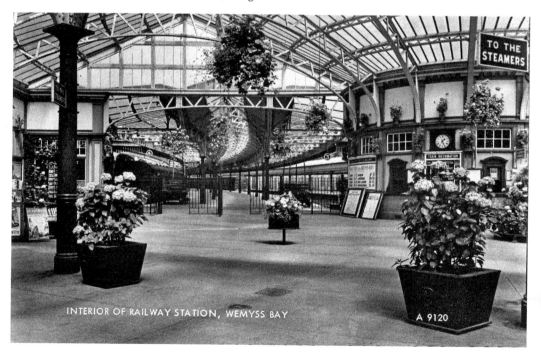

James Miller's Wemyss Bay Station.

Renfield Street

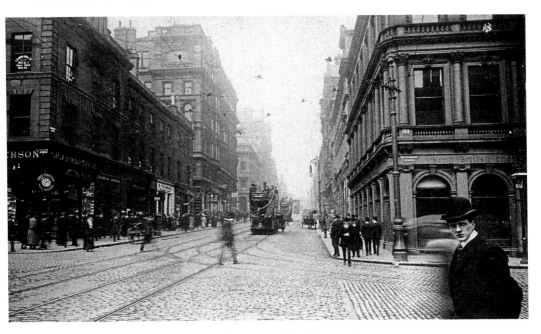

Edwardian Renfield Street, seen at the corner of St Vincent Street.

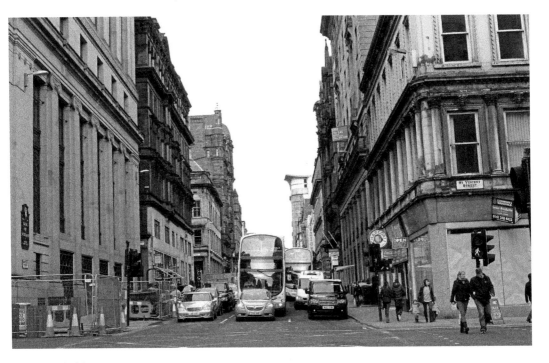

Renfield Street, 2012
Heavier traffic, even on a Sunday morning. Some of the buildings are still the same, but the frontages have been re-modeled. The heavily influenced Union Bank of Scotland building, seen first left, is another of James Miller's buildings.

Hope Street

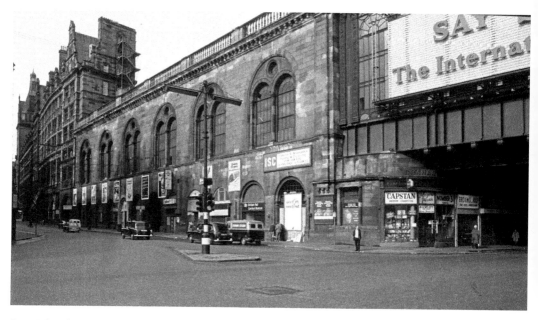

Dag Nilsen's 1970 image looking up Hope Street shows the grimy façade of the station. This is a strangely quiet corner, possibly on a Sunday morning as the newspapers were delivered. The *Evening Citizen* advertised on the side of the van was a long-lived paper from 1877 to 1974, when it ended publication. The *Green Citizen* was the additional weekend version with football results.

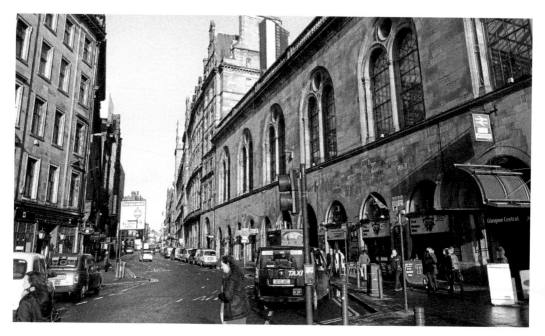

Hope Street now. The cleaned up façade shows the absence of advertising hoardings and is a much more imposing sight.

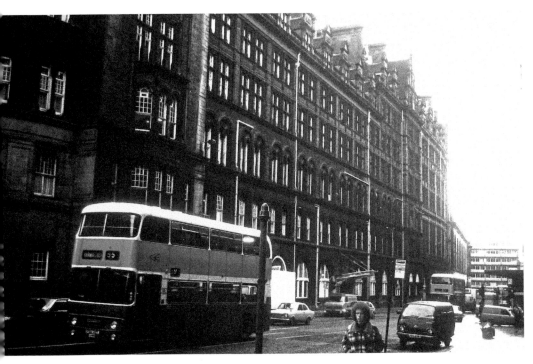

Hope Street on a very dreary November day in 1979. Corporation buses are still in evidence, as is the large haircut. The hotel really needs a clean-up. This shows the scale of the coming task.

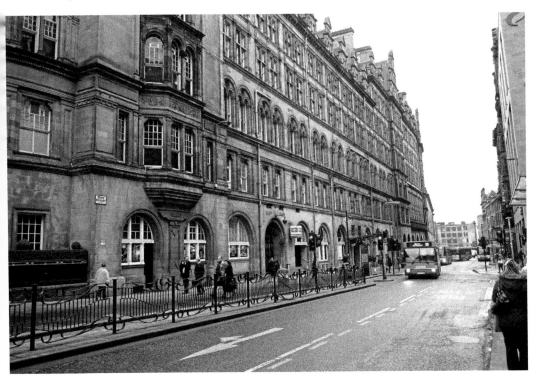

2013 – a good job well done.

Gordon Street

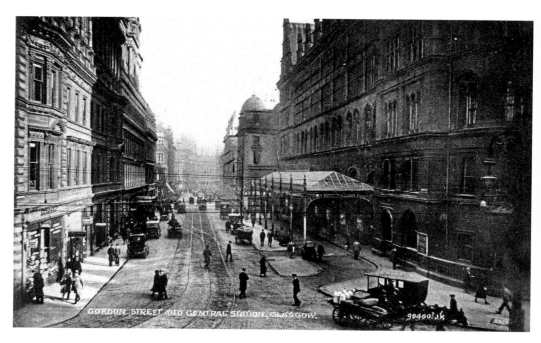

Above: Gordon Street and Central Station, looking through the grid to Buchanan Street.
Below: Gordon Street in November 2012. Virtually all the buildings are the same, although re-modeled. Many of these are listed buildings. On the left with the columns is Alexander 'Greek' Thomson's Gordon Street Warehouse, also known as the Grosvenor Building.

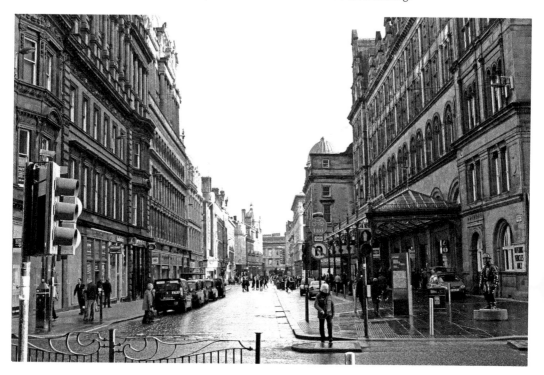

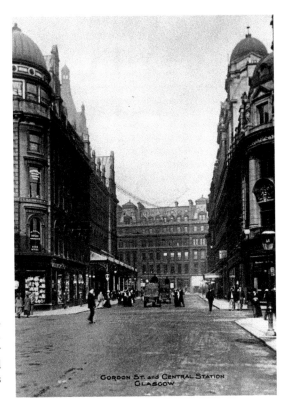

Gordon Street and Central Station. On the right hand corner is R. W. Forsyth's. This was a department store designed by J. J. Burnett. The success of the store led to Forsyth also opening a store in Princes Street in Edinburgh.

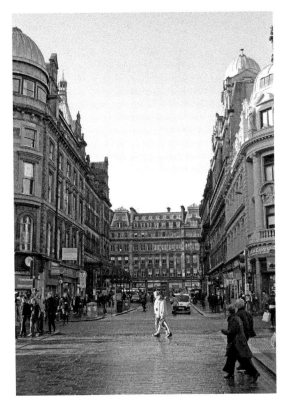

Gordon Street, November 2012.

The Grand Central Hotel

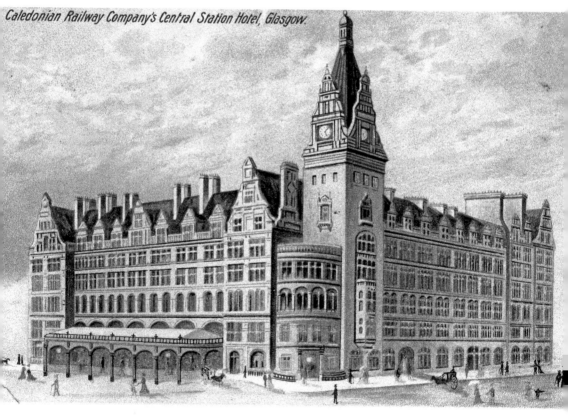

Caledonian Railway Company's Central Station Hotel, Glasgow.

Above: Easter 1906, the Caledonian Railway Company's Central Station Hotel: 'My dear Florie. We are having a good time & splendid weather. I can recommend this hotel should you visit Glasgow. Love to yourself and kisses to Baby. JG Wright.'

Opposite: The Grand Central Hotel, Glasgow, at night.

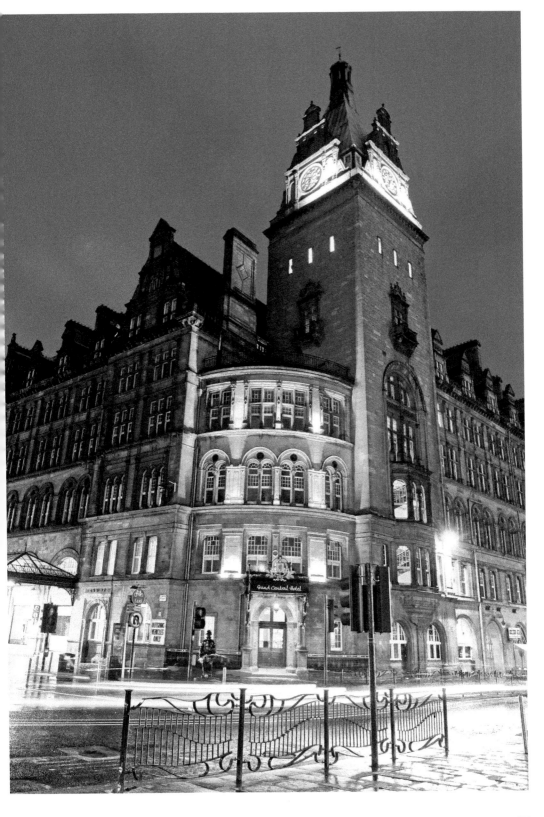

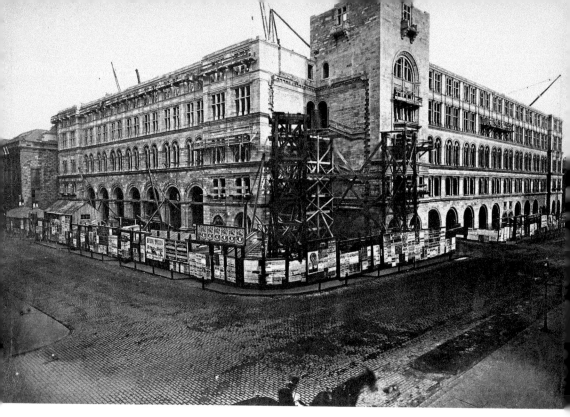

Glasgow Central Station in progress.

Robert Rowand Anderson was one of Scotland's great Victorian architects. From Liberton and George Watson's College in Edinburgh, Anderson served his architectural apprenticeship in Edinburgh before moving as an assistant to George Gilbert Scott in London. Returning to Edinburgh, he worked for the Royal Engineers and had set up his own practice in Edinburgh by 1868.

Anderson is credited with work on many prestigious Scottish buildings and many of these show the influence of Gilbert Scott's work on churches and his advocacy of the Gothic Revival Movement. Gilbert Scott's huge portfolio included the iconic Midland Hotel in Manchester, St Pancras Station and Glasgow University, Gilmorehill. Anderson's work included the Scottish National Portrait Gallery and the amazing Catholic Apostolic Church, now the Mansfield Traquair Centre in Edinburgh.

In 1876, Anderson was appointed architect for the Caledonian Railway's Glasgow Central Hotel, fronting what was originally Gordon Street Station. The Gordon Street buildings had originally been planned as offices for the Caledonian Railway, but it opened as a hotel in 1885 and, along with the station, was subject to the expansions affecting the station between 1901 and 1906.

Opposite above: January 2012 – with the extension.

Opposite below: The Dining Room, the Caledonian Railway's Central Station Hotel.

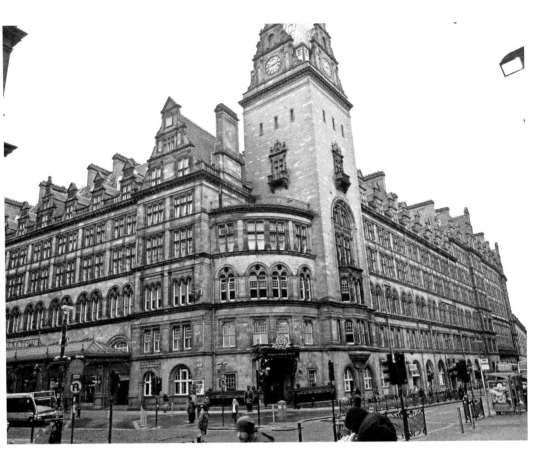

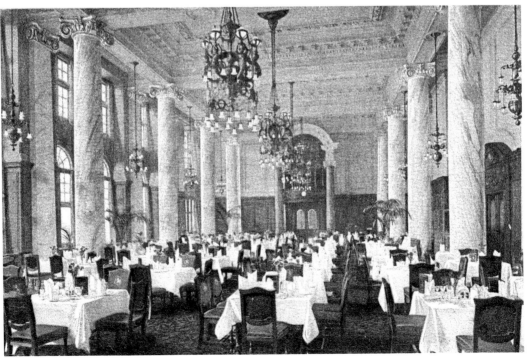

The station buildings had originally been designed as offices for the Caledonian Railway Company but they decided to turn it into a hotel. The Glasgow & South Western owned the St Enoch Hotel, which opened in 1879. Given the previous and ongoing competition, if not antagonism, between the two companies it is possible that the change of use was in response to the opening of St Enoch's Hotel.

Building of the Central hotel is in progress but on the corner of Gordon Street and Hope Street, you can see where the corner has been demolished in order to rebuild it to accommodate the needs of the Hotel. Bearing in mind that it was built as offices, a certain amount of remodeling was required. Looking down Hope Street you can see St Columba's Church of Scotland, 'The Highland Cathedral'. This was moved to a new church in St Vincent Street following the subsequent expansion of the hotel and station. This picture gives a fascinating insight into how these huge buildings were constructed using wooden scaffolding.

The Central Hotel was to become an institution in Glasgow and it would be rare for Glaswegians not to have something to do with it. My own mother worked there occasionally, as a waitress, and I attended functions in it. I also stayed there in its closing years, when the grandeur had faded and when it looked as if it was doomed to become a shame and an eyesore.

However, Glasgow has been in the ascendancy and this has prompted Principal Hayley to re-open the hotel and restore it to the grandeur of former times. The Grand Room Theatre shows both the retention of the former fittings and an updating to modern standards.

The Central Hotel has a rich history. Its visitors have included Laurel and Hardy, Roy Rogers, Frank Sinatra and Winston Churchill. In May 1927, John Logie Baird transmitted the first long-distance television signals to the hotel over telephone cables from London, 440 miles away.

My own fond memories of guests of the hotel were of the European Cup Final of 1960, played at Hampden Park between Real Madrid and Eintracht Frankfurt of Germany. Real Madrid beat Eintracht 7-3 in front of 125,000 spectators in one of the game's most thrilling finals.

The Real Madrid team were staying at the Central Hotel and a number of them came to mass at St Patrick's Catholic Church in North Street, Anderston, where I was a young altar boy. The crowded congregation could hardly contain themselves as a ripple went through that the Real Madrid team were in the church. Outside they were afforded dignity as well as awe. After all, Ferenc Puskas had scored four goals and Di Stefano three to bring them the trophy. And there they were, at my church, the greatest living Spanish footballers, (although Puskas was Hungarian). As the three or four team members walked past my house in North Street on their way along Argyle Street, along with a few other local youngsters I managed to get the autographs of Puskas and Alfredo Di Stefano. It is to my eternal regret that the autograph book disappeared in the mists of my mis-spent youth. In the same book, by the way, were autographs of those great Glaswegians Johnnie Beattie and Larry Marshall. Not so valuable, but maybe just as sentimental.

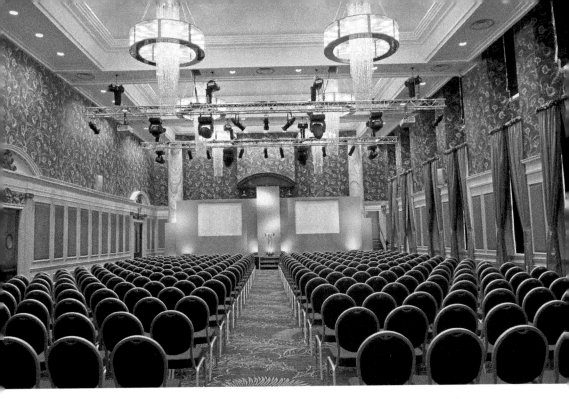

The Grand Room Theatre now – many of the original features have been retained.

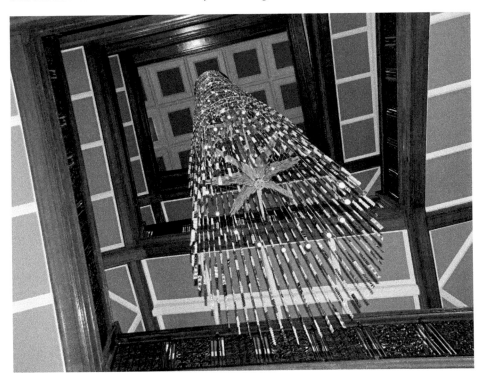

The chandelier in the Grand Central Hotel.

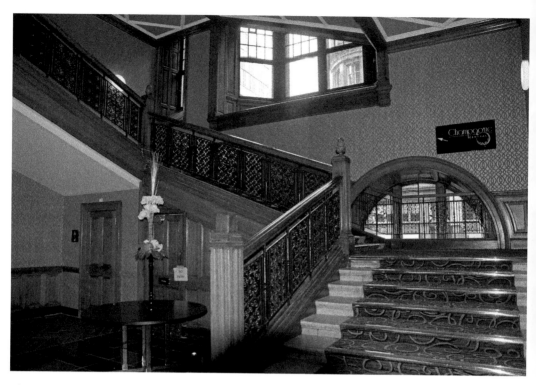

The staircase in the Grand Central Hotel.

The Malmaison in the 1970s.

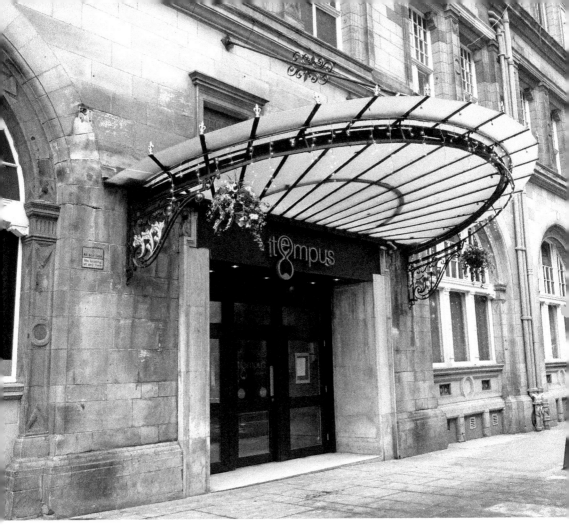

The entrance to The Tempus, previously The Malmaison, seen in 2013. The Malmaison was advertised as 'Glasgow's distinguished French Restaurant'. Opened in 1927, the 'Mal' as it came to be known was named after Napoleon and Josephine's home in France. The menus were unashamedly haute cuisine. In 1984, after 60 years, as tastes, times and fortunes were changing, the restaurant became an 'American' diner and served its last posh meals. Glaswegians saw it as a very expensive place to eat. The Reo Stakis Organisation and Berni Inns had revolutionised the way Glaswegians had a 'night oot'. Stakis Steakhouses, 'Bierkellers' and hotels throughout the city had offered restaurant meals at reasonable prices. The Glaswegian palate had not yet risen beyond well done steaks and Blue Nun Liebfraumilch, but they certainly wanted to go out and not pay huge prices for the privilege. I have to admit that my tastes and pocket only stretched to the Berni Inn, also in Hope Street. I also have to confess to an uncultivated palate – my choice was the very popular Hungarian 'Bull's Blood' wine.

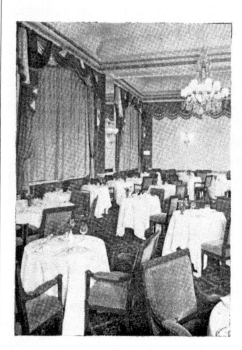

IN THE CENTRAL HOTEL

THE

MALMAISON

Glasgow's distinguished French Restaurant

Reservations: Central 9680

LA

FOURCHETTE

for quick meals before and after the theatre

AMERICAN BAR

Above: Advert for The Malmaison.

Below: The Tempus Bar.

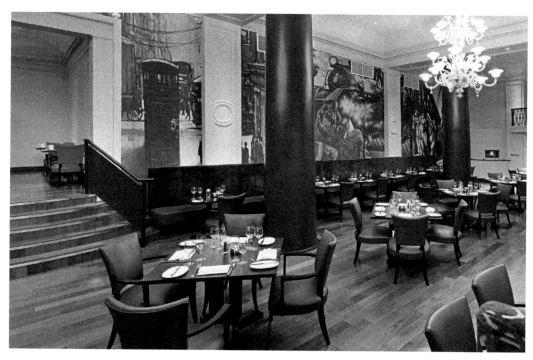

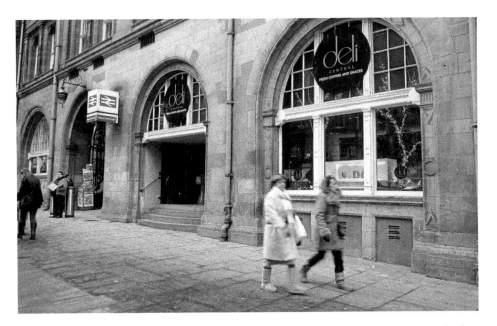

La Fourchette as was, now the Deli Central. Adjoining the Malmaison, La Fourchette had its own chef. It offered lower prices and quicker meals for the business lunch. The restaurant opened in 1952 and closed at the same time as the Malmaison.

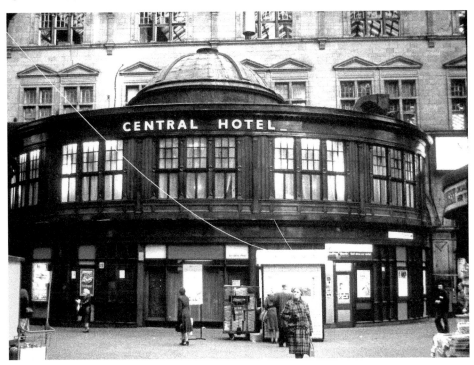

November 1979
The 1980s saw a lack of investment in the hotel and a steady decline. The recent investment in the hotel has seen a remarkable turnaround. Within the domed lounge of the Grand Central Hotel is the chic Champagne Bar.

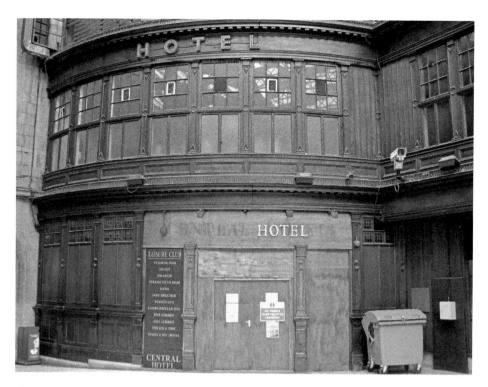

The rear entrance to the hotel in August 2009. Restoration works have just started.

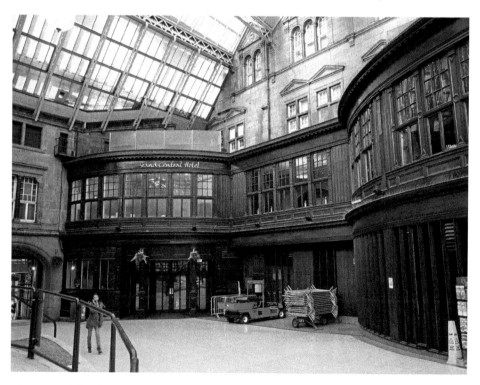

The restored hotel rear entrance.

'Citizen Firefighter'
In front of the hotel stands this memorial to all firefighters, past and present, of Strathclyde Fire and Rescue. I am particularly proud of this as my mother was a firewoman in the National Fire Service, predecessor to the SFR.

Grand Central Hotel

The Railway Bridges

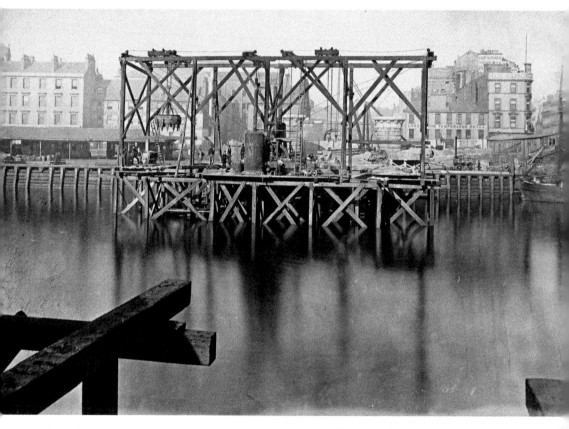

The early stages of the construction of the new bridge, looking northwards to the Broomielaw. What we may consider to be primitive methods of construction would have been state of the art to the Victorians. Here, huge wooden scaffold support a mechanical grab lifting materials from the river bed. This looks as if it would be dropped with great force to penetrate the sand and gravel. The fact that this was the arrival point for thousands of travellers from the Highlands and Ireland might explain the number of temperance hotels along the Broomielaw.

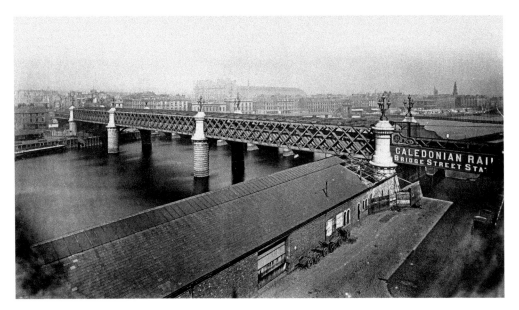

Caledonian Railway Bridge from the south bank before the construction of the King George V and the new railway bridge. You can see that the top bracing girders are almost level with the top of the lattice. These were later raised. I believe that at one time there was an entrance under this bridge with a passage leading up to Bridge Street Station – you can still see the entrance. This allowed transfer of passengers from the station to Bridge Wharf, on this side of the river.

When the Caledonian Railway Company finally got the approval to cross the Clyde, they did it with style, bringing in the services of Edinburgh consultants Blyth & Cunningham and the great Glasgow engineer Sir William Arrol to design and build their first bridge, because there were, in fact, two.

The bridge was designed for four tracks and rested on piers of Dalbeattie granite on top of cast-iron cylinders sunk into the river bed. The first bridge can easily be identified in later photographs as the one which has the high, arched overhead lattice structures. These high arches were a later addition as the permanent way had to be raised to the same level as the second bridge. This involved raising the arches to allow clearance.

The first bridge was remarkable in that it was such a large wrought-iron structure. We are familiar with cast iron, where molten pig iron is poured directly into moulds to produce a wide variety of goods. Its close relation is wrought iron, which has very little carbon content and where the hot iron can be wrought (worked) into the desired shape just as a blacksmith would do with horseshoes. It was the development and spread of both these processes throughout Scotland's Central Belt which was to establish its place in the industrial revolution. Both cast iron and wrought iron were fundamental to shipbuilding and engineering. While cast iron manufacture continued, wrought iron was gradually replaced by the more advanced malleable iron and eventually by the introduction of steel. Arrol's first bridge must have been reaching the limits of wrought iron and probably accounts for the overhead strengtheners.

The crossing of the Clyde came at a cost to the Caley as the Clyde Navigation Trustees were putting up a fight. It cost £95,000 in compensation and the piers of the new bridge had to be in line with the piers of the Jamaica Bridge to allow unhindered navigation.

The bridge was built between 1876 and 1878 and there might have been some concerns given that the Tay Bridge Disaster occurred soon after, during a violent storm on 28 December 1879. The bridge, designed by Sir Thomas Bouch, collapsed while a train from Wormit to Dundee was passing over. The train went into the Tay and all on board were killed. The disaster was blamed on a number of things, including the lack of provision for wind loading and the quality of castings. Bouch had also submitted a design for the new Forth rail crossing but, unsurprisingly, the design wasn't used. The Forth Rail Bridge was built by Sir William Arrol so there were obviously no concerns about quality and reputation. The building of the Forth Bridge showed the advances in metallurgy and engineering in a short period of time as the bridge was the first structure in the world to be built entirely of steel.

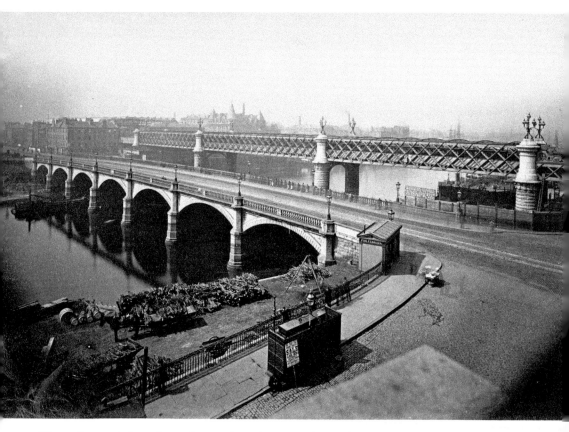

The railway viaduct from the north side. Note the Walter McFarlane Saracen Foundry gentlemen's urinal and, leaning against it, a street advertising board with the poor chap supposed to be holding it taking a rest at the end of the structure. There is still a ladies' toilet in the same place. The logs down to the left look like pit props. There is a line of people leaning against the far parapet, possibly watching as a paddle steamer arrives or departs. Sailing ships can be seen in the distance.

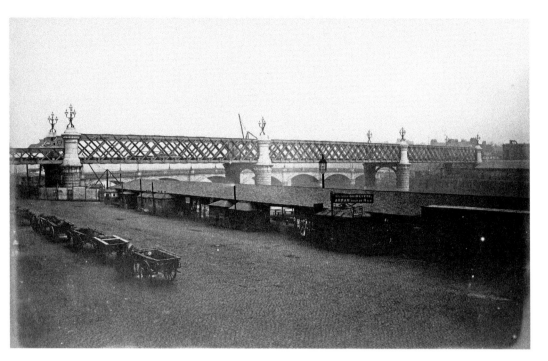

The newly completed bridge, seen from the Broomielaw in 1878. 'Steamer Guinevere sails for Arran daily at 8.00 AM.' The SS *Guinevere*, a paddle steamer, was at that time owned by Keith & Campbell of Glasgow. It was later sold on to the Ottoman government but sank in the Bay of Biscay as it was being delivered to Turkey.

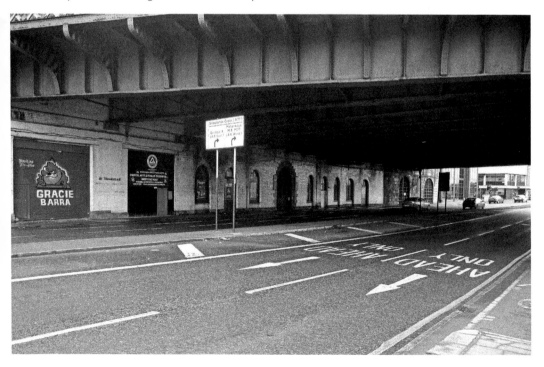

Broomielaw under the bridge.

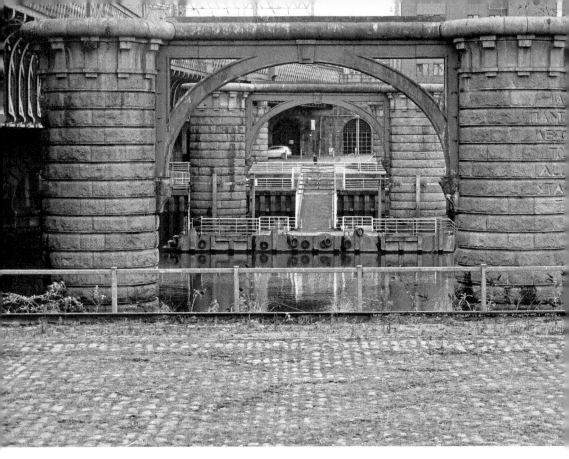

The remains of the first bridge – the cast iron arches were purely ornamental. The bridge was removed by 1967.

The first Central bridge survived to be demolished between 1966 and 1967. It was at the end of its life and new signalling systems had made the new bridge more efficient. However, the removal of the bridge opened up possibilities for the re-use of the piers as sculpture.

Ian Hamilton Finlay was one of Scotland's great innovative and whimsical artists, known for his 'concrete poetry' and his sculptures. Along with his wife Sue, he combined these talents in the building of Little Sparta, a garden in the Pentland Hills. The 5-acre garden contains 275 structures by him and built by many craftspeople.

In 1990 he combined these in re-interpreting the columns of the first bridge as a work of public art. The work was funded by Television South West Arts (TWSA) Four Cities Project. While the project was conceived as producing temporary works, the ingenuity and appropriateness of the project clearly appealed to the funders. TWSA also funded projects in Derry, Newcastle and Plymouth.

The quote is from Plato's *Republic* and a loose translation is: 'For all great things are perilous and beautiful things are hard.' I like to think that a more apt Glaswegian interpretation would be 'It's a hard life if you don't weaken.' Without demeaning Finlay's classical bent, I would think that the latter might appeal to the Weegie. I wonder what those workers on the wooden scaffold sinking the piers would have thought of it.

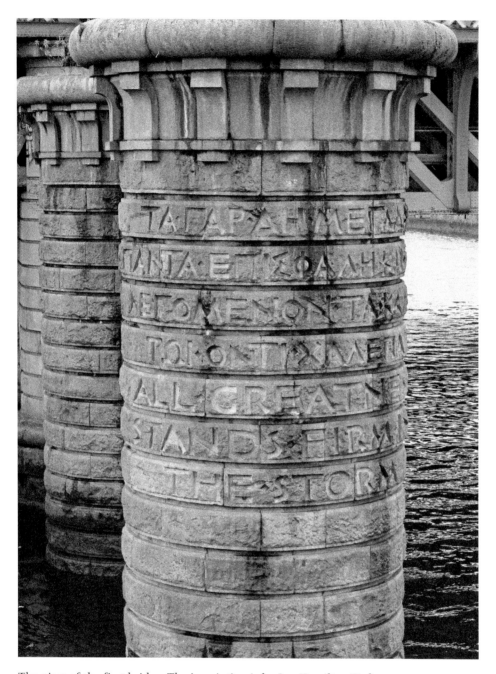

The piers of the first bridge. The inscription is by Ian Hamilton Finlay:

ΤΑ ΓΑΡ ΔΗ ΜΕΓΑΛΑ
ΠΑΝΤΑ ΕΠΙΣΦΑΛΗ ΚΑΙ ΤΟ ΛΕΓΟΜΕΝΟΝ ΤΑ ΚΑΛΑ
ΤΩΙ ΟΝΤΙ ΧΑΛΕΠΑ

ALL GREATNESS
STANDS FIRM IN
THE STORM

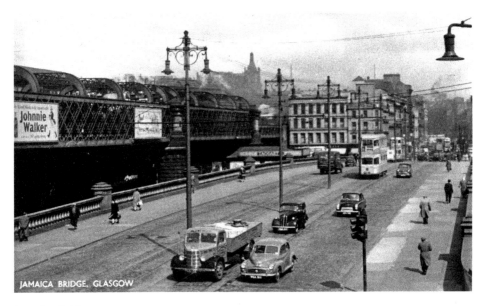

Jamaica Bridge, *c.* 1950

The lattice structure of the first bridge can be clearly seen, as can the piers and the arches which were raised to allow the permanent way to be raised in line with the new bridge. The tower of the Central Hotel can be seen in the distance.

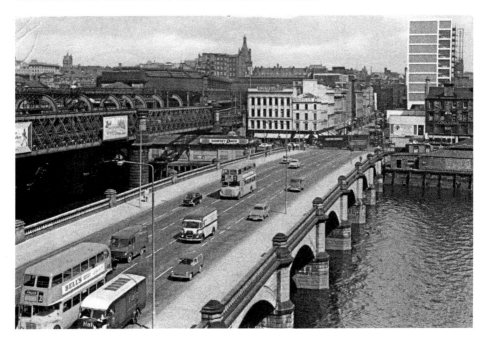

Jamaica Bridge

Whisky was well advertised here, and macaroon bars too – 'Lees, Lees, more if you please, best to beg on your bended knees.' Coulson's Stout is advertised on the building next to the new Royal Stuart Hotel, opened in 1965. And Paisley's outfitters, which was well-known to every Glasgow pupil who wore a uniform, can be seen at the end of the bridge. Paisley's closed in 1979. Trams have given way to buses.

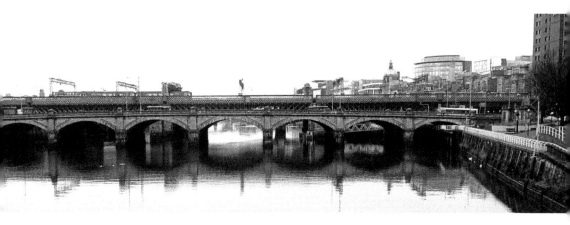

A panoramic view of the bridges.

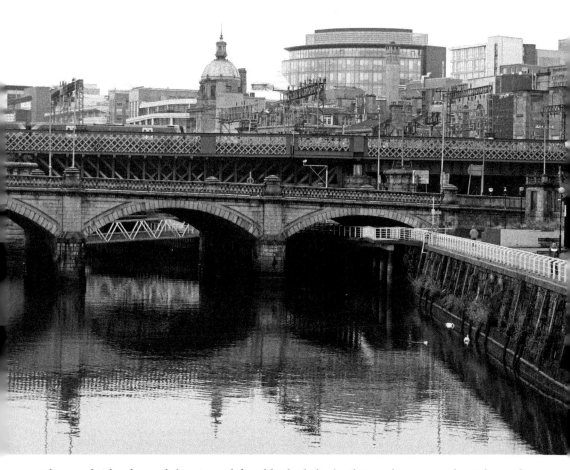

The new bridge, beyond the piers of the old. The ladies' toilet can be seen to the right on the bank.

In parallel with the expansion of Central Station, new lines were also needed and these were planned to run on a massive bridge running parallel to the old bridge. The bridge was built between 1899 and 1905. The engineers were Donald Matheson and Sir John Wolfe Barry. Again, it was built by Sir William Arrol.

Sir William Arrol & Co. will also be remembered as the builder of Tower Bridge in London and North Bridge in Edinburgh, as well as the new Tay Bridge, completed in 1887. William Arrol was one of the greatest Scottish engineers and industrialists. From Houston, in Renfrewshire, he was the son of a cotton spinner and started work in Coat's mills, aged ten. A few years later he trained as a blacksmith with Reid's of Paisley. Like many young Scots entrepreneurs of the time, he undertook night classes, learning engineering. At 24 he became a foreman in the Glasgow boilermaking company Laidlaw & Sons, where he was well respected for his engineering skills.

By the time he was 29 he was starting his own engineering business in Dalmarnock. While Sir William Arrol & Company was to produce a wide range of products, including cranes, and equipment for gas and steel works, his reputation was surely founded on his railway engineering works. One of his first major railway contracts was the building of the Caledonian Railway bridge over the Clyde at Bothwell. Sir William Arrol was to go on to build the replacement Tay Bridge, the Forth Bridge, Tower Bridge in London and bridges and cranes worldwide. Through this, his innovation and creativity shone through. This included the invention of pneumatic riveters and, with William Foulis, a patent drawer and stoker for gas furnaces. He also financed the manufacture of the famous Scottish Arrol-Johnston car in Camlachie, Glasgow.

He became Liberal Member of Parliament in 1895 and served for 10 years. He died in 1913 and is buried in Woodside Cemetery, Paisley.

Sir William Arrol & Company continued in business until 1969, when it was taken over by Clarke Chapman. The Dalmarnock Iron Works were closed in 1986.

But back to the second bridge, which is supported on granite faced cylinders, these built on rectangular steel caissons filled with concrete. It cost £200,000 and again the Clyde Trustees did well out of it, being given £75,000 for the right to cross. With completion, there were now a total of thirteen tracks running into Central Station. Just to make sure that it was as sturdy as it looked, it was load tested with nineteen locomotives before its opening in 1905.

Earlier we mentioned that Central Station was associated with one of our longest lasting companies, John Menzies. Another such reputable Scottish company is Blyth & Blyth, still based in Edinburgh, at the Gyle, to where they moved from 135 George Street. As Blyth & Cunningham they were the original consultants for the Central Station and the first railway bridge.

Blyth & Blyth had its origins in Benjamin Hall Blyth's civil engineering practice in 1848. They were substantially involved in road and rail infrastructure and this included Edinburgh's North Bridge and Waverley stations as well as Glasgow Central Station.

Benjamin Hall Blyth, junior, was apprenticed to his railway engineer father in 1867 after receiving his MA at Edinburgh University. He became a partner in 1871. At his father's death in 1866, the firm was being run by David Munro Westland and George Miller Cunningham under the name of Cunningham, Blyth & Westland. After Cunningham's retirement in 1893 it became Blyth & Westland, taking the present name Blyth & Blyth when Westland retired in 1913.

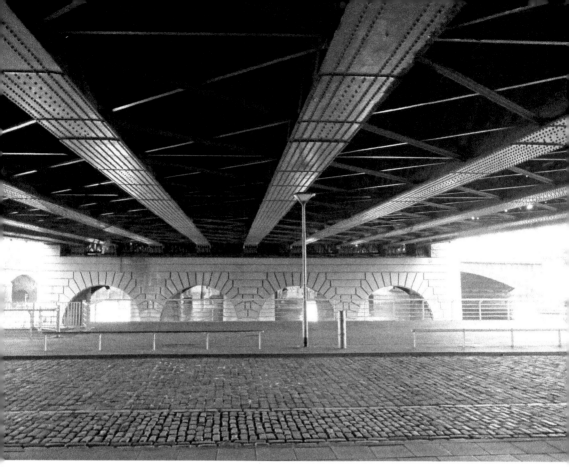

A view taken underneath the second railway bridge. The scale of the bridge can be seen in the massive arches and piers.

In 1914 Benjamin Hall Blyth had the rare distinction of being the first practicing engineer in Scotland to be elected President of the Institution of Civil Engineering.

Following the Great War, there was a recession and very little construction work was being undertaken. Blyth & Blyth began work for the Ministry of Transport and local authorities in road and bridge construction. They also provided consultancy to mills, breweries and factories.

During the twentieth century Blyth & Blyth has remained at the forefront of the UK's multi-disciplinary engineering consultancies. Their clients include many well known companies including BAE Systems, Chivas Brothers, Diageo, Standard Life and many local authorities and government departments and agencies. This year Blyth & Blyth celebrates 165 years as an independent Scottish company.

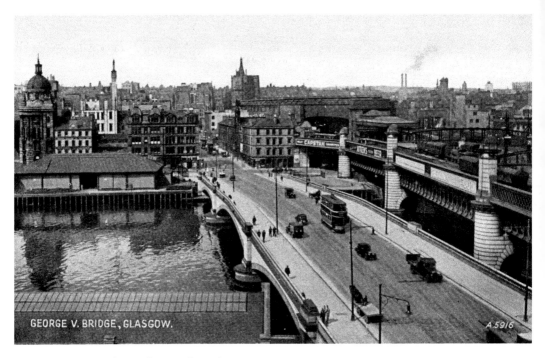

King George V Bridge and Central Station
This image dates from after 1928. Although the bridge was planned prior to the First World War, it wasn't started till after the war, with King George V opening it in 1927.

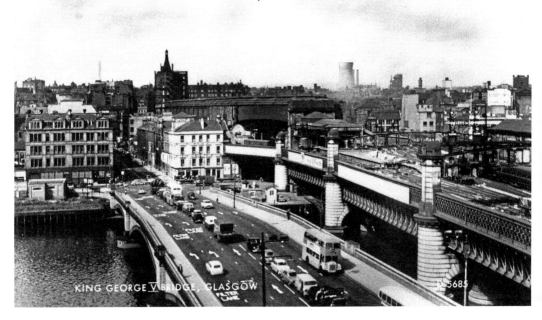

King George V Bridge in the 1960s
Buses have replaced trams; the Broomielaw sheds have disappeared; and in the distance you can see the new cooling tower for the Pinkston Power Station. Otherwise, the landscape is very much the same.

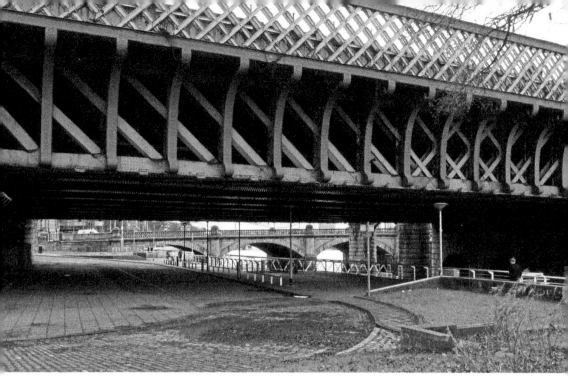

The new bridge frames the Jamaica Bridge. All evidence of river trade has disappeared.

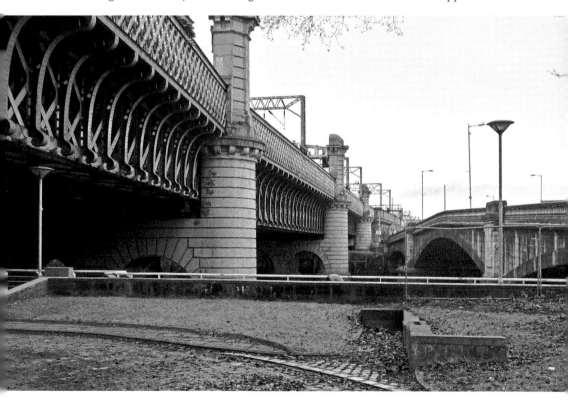

Looking towards the south from the Broomielaw.

This Way to the Trains

Yes – I was a train spotter, complete with the Ian Allan trainspotter's guide to steam locomotives. It seems amazing to me that only a few years after R. M. Casserley took his amazing photographs of Glasgow Central Station, I was standing on the same platforms taking down the numbers of probably the same locomotives and, on at least a couple of daring occasions, getting a 'hurl' on the station shunters. You wouldn't imagine that now. Glasgow Central Station was my patch. It was here that I would watch the thronging masses come and go, and where I would set off with my parents 'doon the water'. While I ventured to St Enoch and Queen Street stations, and occasionally to the farther flung and quieter Buchanan Street Station as well as the St Rollox engine sheds, it was Central which was my favourite.

Through the years, I have travelled by train in and out of the station and walked through it, as it really is a covered square. I have seen the changes in the buildings, the changing fortunes of the Central Hotel. I have visited the mock-ups of new train designs as they were presented to the travelling public. And most recently I was a 'Wiglie' ('Works in Glasgow, lives in Edinburgh'), commuting from Edinburgh to Central on the now discontinued East Coast service. If you were to ask me what experience in Scotland would be my favourite, among the top would be coming into Glasgow Central Station over the river Clyde on an early morning.

My visits to Central station started in the steam era. The steam engines gave way to diesel and electrics, not all of these successful, but I am glad to say that while I lost my trainspotter records, photographers like Mr Casserley were recording the end of an era and the introduction of new locomotives and trains, some of them famous. Some of them are here.

Opposite above: This photograph was taken by R. M. Casserley on 12 September 1955, a bright day. The Travelling Post Office (TPO) is attached to a shunter, St Rollox-built No. 55237, Pickersgill Caledonian Class 431. The TPO has presumably arrived from Euston, having been hauled by a Royal Scot or a Pacific. I particularly remember posting letters in a postbox at the end of the TPO before it left Central Station in the evening – probably football pools coupons for my dad. TPOs were daily visitors to terminal stations. Vans from the General Post Office would deliver bags to the waiting trolleys to be taken to the trains and you could watch the GPO staff already starting to sort the mail before the trains left. It was a TPO from Glasgow Central Station to Euston that was robbed in the Great Train Robbery of 1963. By that time, the TPOs were hauled by diesels. TPOs were withdrawn in January 2004. In the background is BR No. 80056, a Derby-built Class BR 4MT. Based at the Polmadie sheds, these would be used for commuter lines round Glasgow. In 1955, this would have been a relatively new engine.

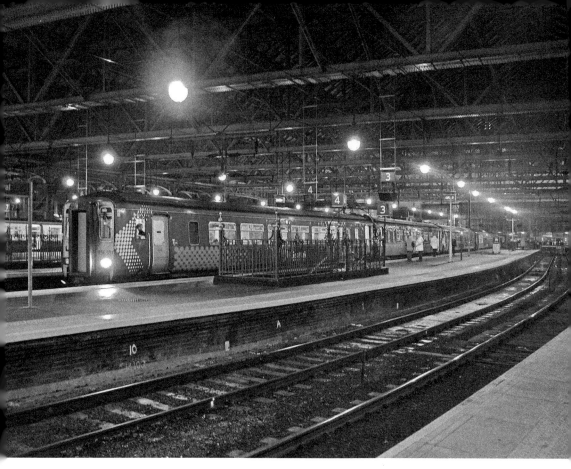

A modern panorama inside the station.

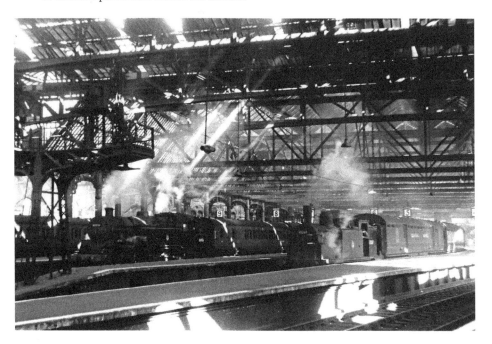

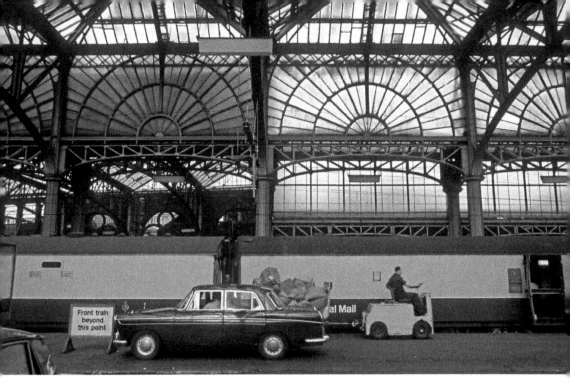

The TPO is seen here in July 1970, still using jute sacks. You can see the post box on the side of the wagon.

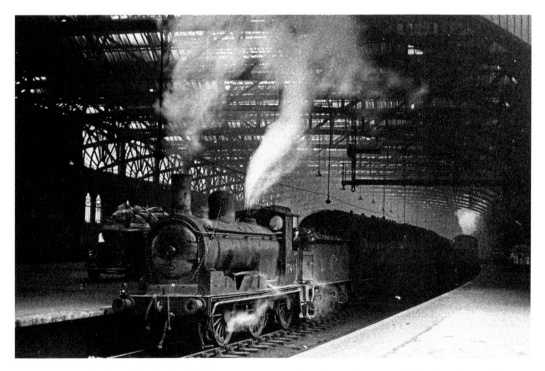

This photograph of ex-Caledonian Railway 17447 was taken in October 1946. In the background, a lorry stacked with mailbags can be seen.

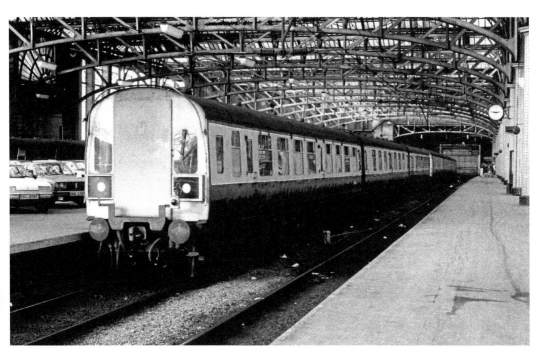

This is the same platform, but 36 years later. Taken in February 1982, this photograph shows Electric Multiple Unit (EMU) SC 51020.Everything is much cleaner. Note also the fluorescent lights and electric clock.

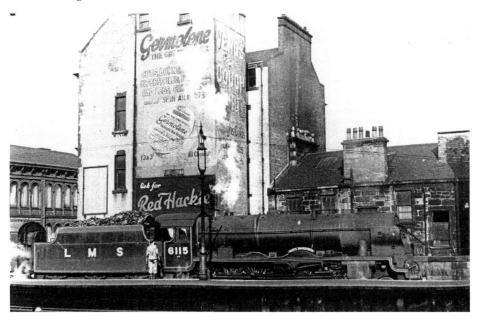

The 5.40 to Euston, hauled by 6115 *Scots Guardsman*, is seen here in April 1948. This is a rather famous engine, having starred in the 1936 film *The Night Mail*. I wonder if you can still get this kind of Germolene? It seems to cure everything. 'Red Hackle' whisky was produced by Hepburn & Ross, based in Otago Street, Glasgow. The hackle is a feather plume attached to a military headdress. The red hackle is worn by the Black Watch.

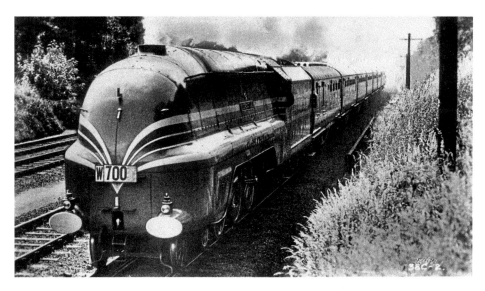

The Coronation Scot

The Coronation Scot was an LMS express between London Euston and Glasgow Central. It was named at the Coronation of King George VI in 1936 and entered service in 1937. It ran until the outbreak of war in 1939 and stopped only at Carlisle to change crew. Its scheduled time was a fast 6 hrs 30 mins.

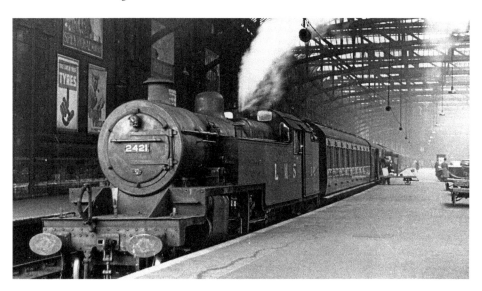

This is A Fowler 4P, built at Derby in 1933 and based at Greenock at the time this photograph was taken. Advertisements once were a common feature of railway stations. Here, the walls above the train to the Clyde coast are festooned with adverts for beer, whisky and matches. Also, 'Take care of your tyres' – early road safety. This was, and continues to be, a platform for the trains running down the Clyde coast. I remember, in the 1950s, queuing here to get on to possibly the same train to go down the coast to board a paddle steamer from Gourock to Dunoon. Those trains, like the one pictured here, had similar doors and single compartments. This had difficulties for young children, which were usually overcome by parents. The same was true for the crowded and smelly steam trains setting off for Saturday afternoon football matches at Kilmarnock.

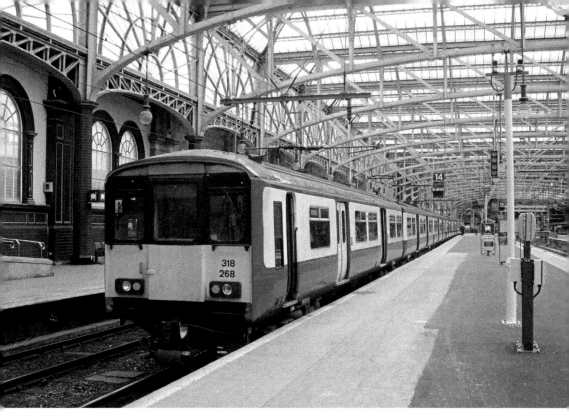

A Class 318 at Glasgow Central in July 2010. The train now has toilets, and the station is very much cleaner.

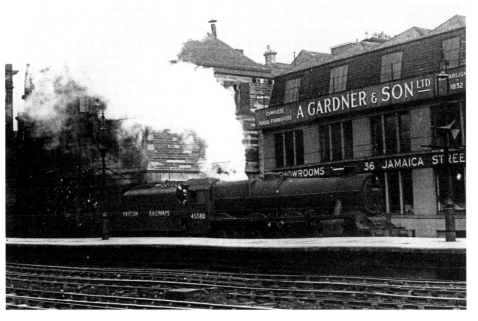

In February 1950, BR Stanier 45580 *Burma* was photographed against the rear of A. Gardner & Sons' shop.

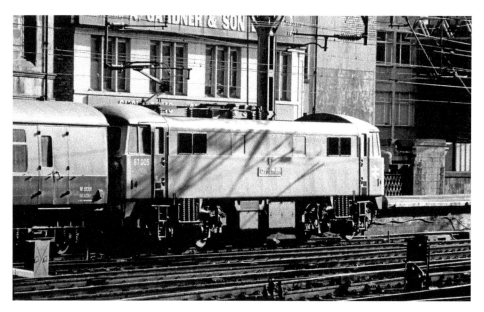

Almost 32 years to the day, 87005 *City of London* sets off to Euston on 13 February 1982, but the service is now electrified. Full electrification to Glasgow was completed in 1973/4 and this saw the introduction of new British Rail Class 87s. The formal title was Royal Scots, although they were better known as the Electric Scots. The Electric Scots were built by British Rail Engineering (BREL) and were long-lived locomotives, eventually being superseded by Virgin Rail's new Pendolino. The *City of London*, shown here, was the first of the class to be formally taken out of service, in June 2005. Many of the redundant locomotives were exported to Bulgaria.

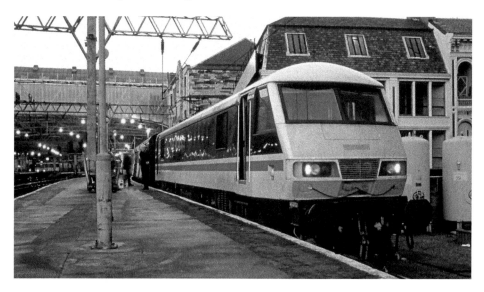

Platform 1 again, but six years later. Class 90 No. 90008 in InterCity livery is seen waiting to depart from Glasgow Central with the 1710 to London Euston in November 1988. The British Rail Class 90 electrics were again built by BREL at Crewe between 1987 and 1990. They were also used for the Glasgow to London Euston run before the Virgin Pendolino and are still currently used on First Scotrail's Caledonian Sleeper Service.

ALTERED TRAIN ARRANGEMENTS AT

GLASGOW (Central)

On SUNDAYS, 8th MARCH to 3rd MAY, 1959

No trains will leave from or arrive at CENTRAL Station, Glasgow, on Sundays between 8th March and 3rd May, 1959, both dates inclusive, because of the installation of new signalling equipment at the station—a further stage in the work in connection with the electrification of the Glasgow Suburban lines.

During the period mentioned above, trains which on Sundays only would leave or arrive at CENTRAL station will leave from or arrive at ST. ENOCH or BUCHANAN STREET stations as shown below:—

TRAINS TO ENGLAND

The following trains to LONDON will leave from GLASGOW (St. Enoch) Station:—

9.40 a.m. to LONDON (St. Pancras)
9. 5 p.m. to LONDON (St. Pancras)
10.20 p.m. to LONDON (Euston)
(retimed to leave at 10.10 p.m.)
10.25 p.m. to LONDON (Euston)

TRAINS FROM ENGLAND

The following trains from LONDON will arrive at GLASGOW (St. Enoch) station:—

*10. 0 p.m. (Saturday) from LONDON (Euston)
11.20 p.m. (Saturday) from LONDON (Euston)
9.15 p.m. (Saturday) from LONDON (St. Pancras)
10. 0 a.m. from LONDON (St. Pancras)

* Commences 4th April

ALL OTHER TRAINS TO AND FROM ENGLAND WILL LEAVE FROM AND ARRIVE AT BUCHANAN STREET STATION

(Over)

Right: Arrangements for electrification at Glasgow Central.

Below: Beside the smells of steam, there was also the smell of paraffin lamps. These were attached to trains as warning lights, as can be seen in this image from April 1948.

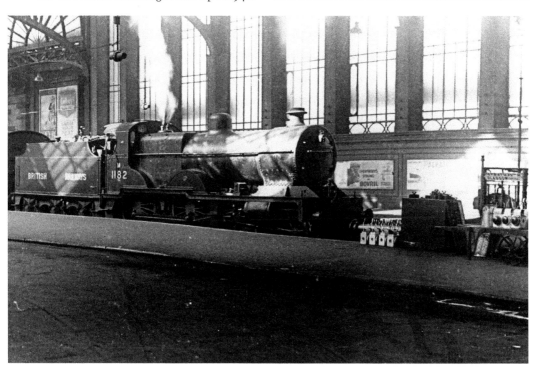

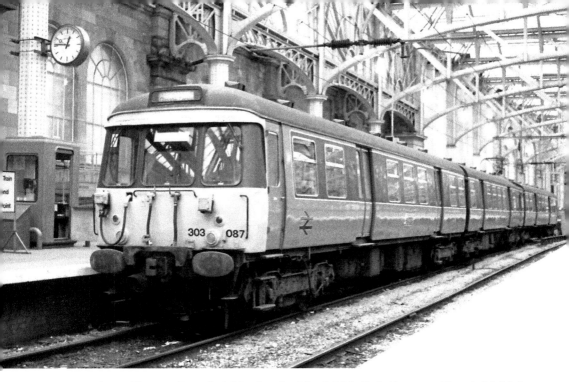

303 087 at Glasgow Central, 6 March 1987. The British Rail Class 303 Electric Multiple Units (EMU) were introduced in 1960. Known as the Blue Trains, I travelled on them in their first month with my dad. My recent experience had been on steam trains to school and the new coaches were exiting, spacious, comfortable and warm and were later to make my journey to work from Scotstoun to Coatbridge both possible and tolerable. Like this set, they were also used on the Cathcart Circle, this one in the livery of the Strathclyde Passenger Transport Executive.

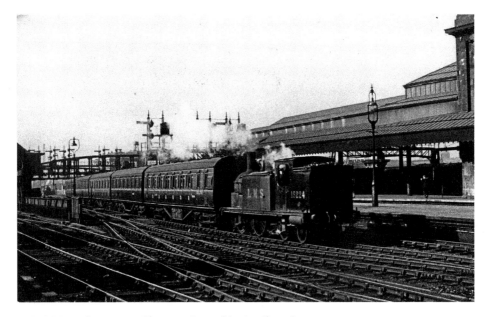

LMS McIntosh 15224 at Glasgow Central in April 1948.

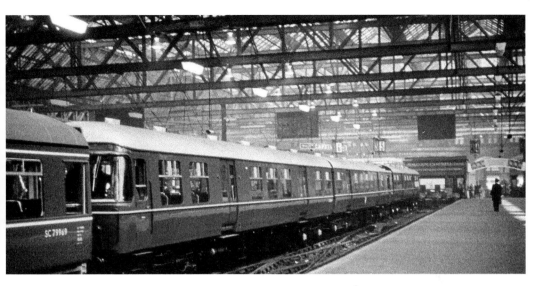

At platform 5 in 1960, we see a brand-new, recently introduced Class 303 Electric Multiple Unit, known as 'The Blue Train'. These were first introduced in the north of the city and on the Cathcart line. They revolutionised travel into Glasgow and made my journey in the late 1960s from Scotstounhill to Coatbridge Sunnyside more bearable in the early hours of the morning. In the distance you can see that Malcolm Campbell's shop is still going.

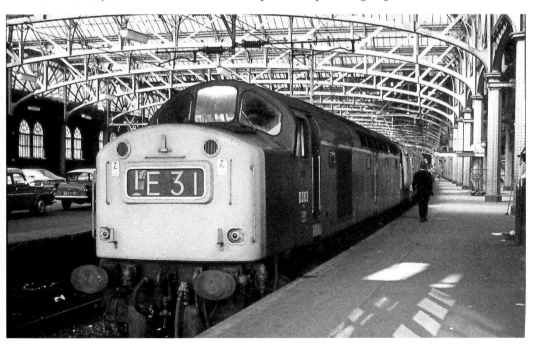

Class 40 No. D383 is seen here waiting to depart from Glasgow Central with 1E31, the 1525 to Leeds, on 20 August 1971. The British Rail Class 40 was a diesel locomotive built by the English Electric company from 1958 to 1962. Two hundred in all were built and while they were very useful, they nevertheless began to be replaced by more powerful locomotives and found themselves on freight movement and shorter passenger journeys such as Glasgow to Leeds. They were finally retired in 1985, the locomotive seen above in 1983.

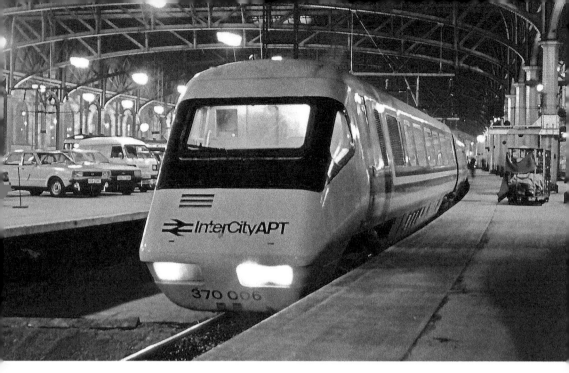

InterCity APT 370006, seen after arriving at Glasgow Central with the 1630 hrs from London Euston on 16 March 1984. This was during the period when rail staff could travel on the train to test the facilities and ride of the train.

The Advanced Passenger Train (APT) was supposed to be Britain's answer to France's TGV and in order to cope with the curves which are a feature of many main lines, a tilting mechanism was developed. Three experimental APT-Ps were introduced on the Glasgow–London route. Unfortunately, real or imagined technical problems caused bad publicity. The APT had been developed in the 1970s specifically as a new breed of inter-city train and to deliver faster times on the West Coast Line. The trains would reach 155 miles per hour and they could negotiate curves up to 40 per cent faster than conventional trains.

On 7 December 1981, the train's first public outing from Glasgow Central to London Euston was successful. On the return trip, the tilt mechanisms in some cars stopped working and brakes froze in the cold weather. All of this was bad publicity and contributed to the very quiet demise of the train, even though many thought that the teething problems could be overcome and that the train had been introduced before it was ready. It continued to be used for development purposes and a number of the innovative features found their way into subsequent trains.

It was said that when the APT was being developed, some senior British Rail staff had reservations about the APT and separately commissioned work on an alternative design which would be based on existing technology. This stopgap measure is still in use today and has been one of the most successful train designs, and one which I am very fond of. The project was the High Speed Train (HST), otherwise known as the InterCity 125. Until very recently, the HSTs of the East Coast Service from the south called at Edinburgh before terminating at Glasgow Central. That service has now been withdrawn.

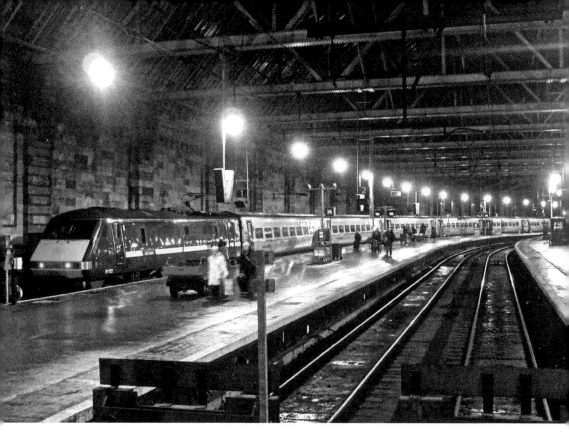

An East Coast HST arrives from London at Platform 1, 2010.

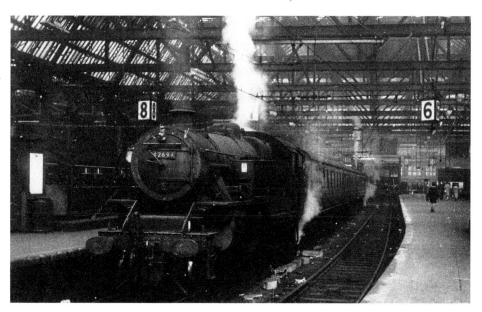

A Fairburn 4P-C which was working out of Polmadie sheds in 1948. This was built at
the LMS Derby Works in 1947 and withdrawn in 1967, although it had been moved to
England in 1963. It was probably superseded by the Blue Trains.

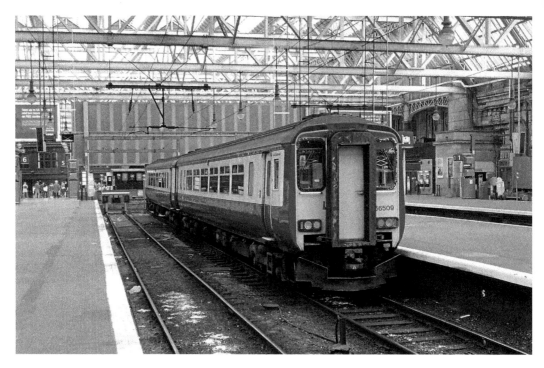

DMU 156509 in Strathclyde Passenger Transport livery awaits its next duty, which will be a service to Kilmarnock.

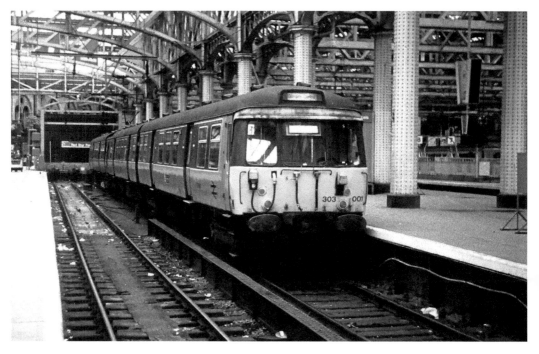

The first of the Electric Multiple Units (EMUs) in SPT livery.

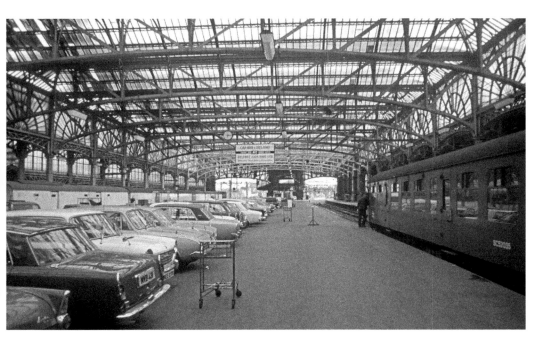

This large platform, seen in 1970, was originally a roadway for horse and carriage giving space to turn. Carriages and carts would enter through a still existing entrance. It later became a car park before being converted to new platforms. At the end of this area was the fruit, fish and milk platform added in the 1905 rebuild. (Dag Nilsen)

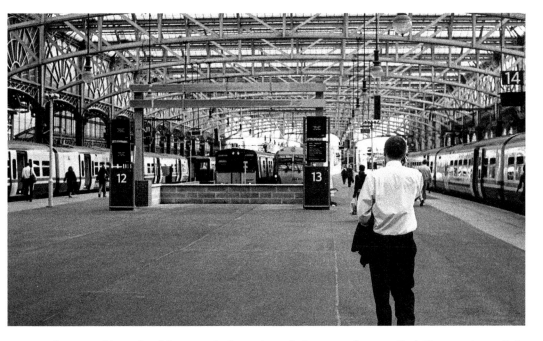

Andrew Lynch's study of the new platforms intended to serve the cancelled Glasgow airport link. The project was proposed in order to link Glasgow to the airport directly by rail and required substantial re-alignment, building and new infrastructure. The project was cancelled in 2009 as part of government spending cuts but the new platform building continued.

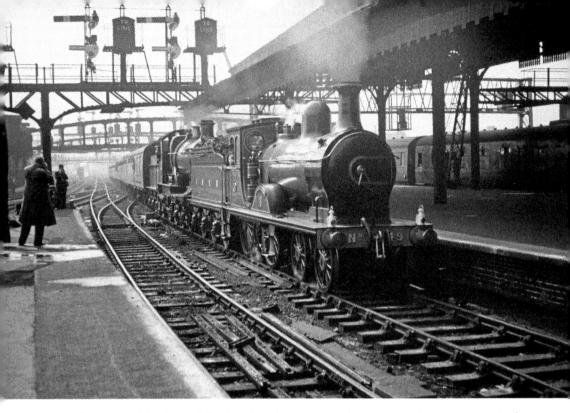

Also approaching Central Station, but about 15 years later: ex-GNSR 4-4-0 No. 49 *Gordon Highlander* leads ex-GWR 4-4-0 No. 3440 *City of Truro* into Glasgow Central on 3 September 1959 at the head of a special. The train was one of several run in connection with the Scottish Industries Exhibition taking place at various locations throughout Glasgow at that time, including the Kelvin Hall.

BRITISH RAILWAYS

LOCOMOTIVE AND ROLLING STOCK DISPLAY
In support of Scottish Industries Exhibition,

CENTRAL STATION, GLASGOW.

3rd—19th September, 1959,
10.0 a.m. until 10.0 p.m.
Daily except Sundays. (A)

JUV⬚⬚ 3d

HALF - HOURLY SERVICE OF TRAINS
FROM GLASGOW CENTRAL (LOW LEVEL)
TO KELVIN HALL RAILWAY STATION
- A FEW MINUTES WALK FROM
SCOTTISH INDUSTRIES EXHIBITION.

Return Fares - Adult 8d. Child 4d.

3818 3818

Ticket from Central Station for the Scottish Industries Exhibition.

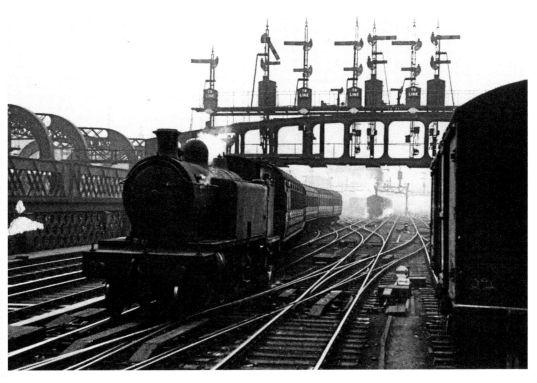

A local train approaching Central Station in April 1946.

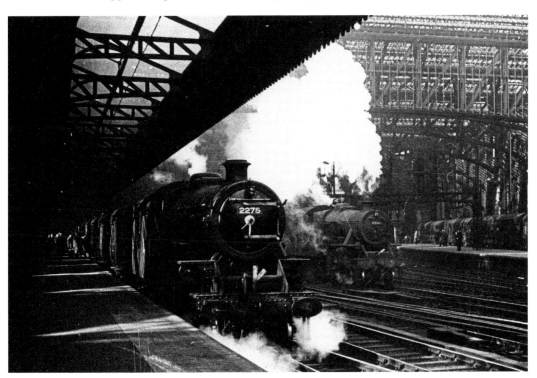

A one-year-old LMS Fairburn, 2275, prepares to leave for Ardrossan in April 1948.

Approaching Glasgow Central Station.

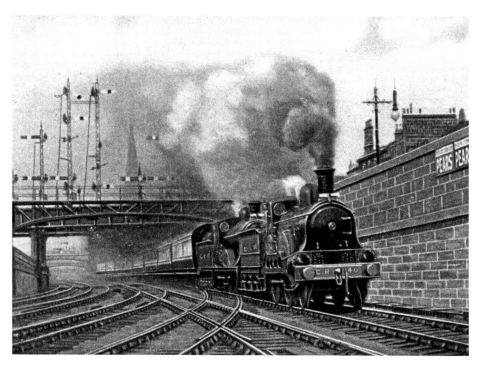

The double-headed 2 p.m. Caledonian Railway express from Glasgow Central, near Eglinton Street. This is taken from a card posted in July 1916.

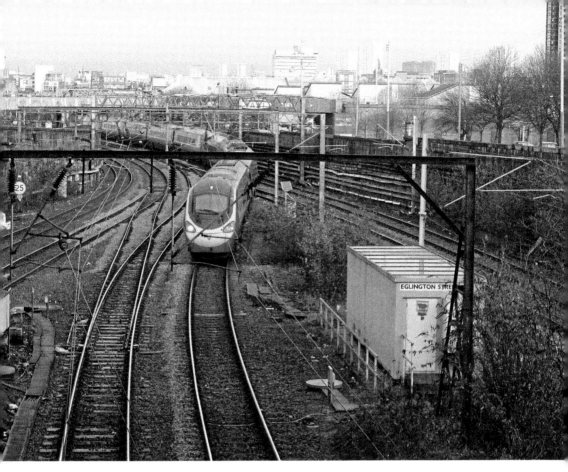

A Virgin Pendelino at the same junction in January 2013, with a lot more greenery and a lot more railway clutter.

Central Station Low Level

I had always thought that the Central Station Low Level was an integral part of the main station. I was surprised to learn that it was originally a separate line and that the station was not directly under Central Station as I had imagined. Most of the station was under the buildings fronting Argyle Street between Hope Street and Wellington Street. Prior to the entrance being built under the main station, there was, temporarily at least, an entrance on the other side of Hope Street on Argyle Street.

The low level station was built for the Glasgow Central Railway (GCR), which was authorised in 1888 and opened in 1896. The Central Railway was taken over by the Caledonian Railway in 1890. Services through the Low Level for GCR and other companies ran from Maryhill Central and Dumbarton through to Carmyle and other destinations in the east.

Much of the railway was closed under the Beeching cuts and it languished as an unused asset under the Glasgow streets until some of it was finally re-opened in 1979. With Argyle Street, Anderston and Finnieston (now known as Exhibition Centre), the line links the north and south of the river and links with services though Queen Street at Partick.

I do remember boarding a steam train at Anderston Cross, probably being taken to a football match to see Celtic play Clyde at Shawfield. Because I remember it, it must have been a memorable experience. From R. M. Casserley's images, you can imagine the smoke, steam and smell in the confined space where you would be jostled by adults pushing into the compartments.

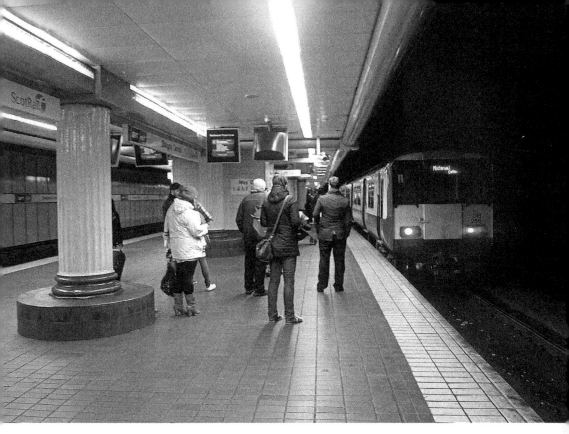

The Motherwell train at the modernised Glasgow Central Low Level.

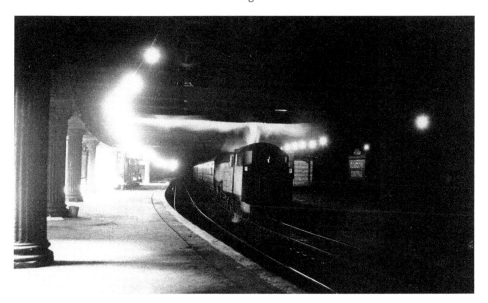

This would be a very difficult photograph to take in the gloom, so there are few images of the low level platforms. R. M. Casserley has done well to get this one, which fairly represents the atmosphere of a steam engine in the confined space and darkness of the tunnels. It was taken in June 1962 and shows engine 42131 and the service from Coatbridge to Possil.

Again, R. M. Casserley has captured the claustrophobic atmosphere under Central Station. This is the Coatbridge to Possil train. You can clearly see into the carriage and almost make out the many pictures which once were a feature of these compartments. These would normally be rustic scenes of the areas serviced by the railway company. The engine is 42131, a Fairburn 4P-C class working out of Polmadie sheds. It was withdrawn from service in 1965.

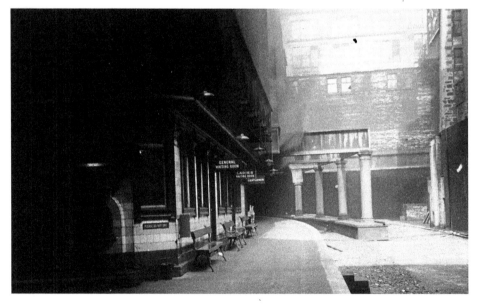

Another view of the Low Level station in July 1957. You can see the smoke emerging from the adjoining platform. There was a high level of smoke from trains, and from chimneys, as well as the regular 'pea-souper' smogs. Smoking, often pipes, was prolific and spitting was common. Perhaps this is a plea not to spit in the fire buckets? Beyond the façade is Wellington Street. Above the station buildings supported on steel beams are a line of shops fronting Argyle Street.

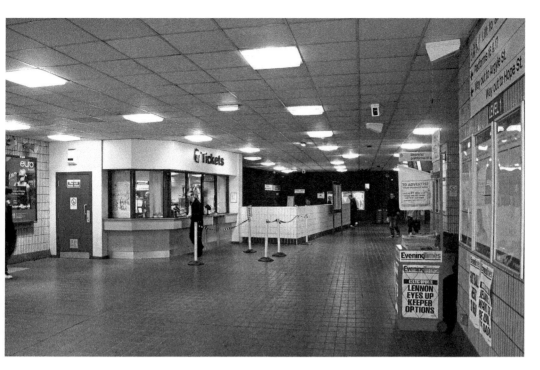

The current entrance to the Low Level station.

The entrance to the Low Level station.

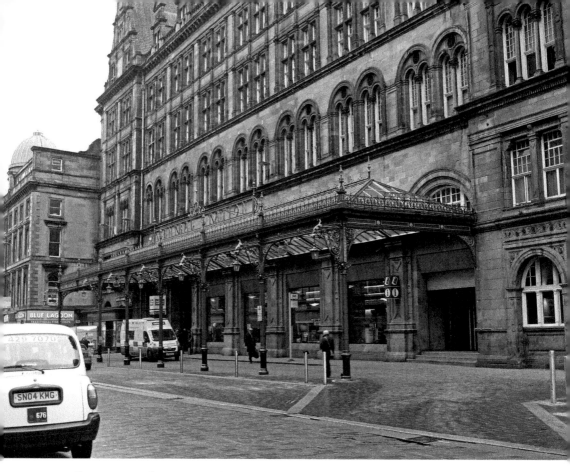

Glasgow Central Station, Gordon Street entrance.

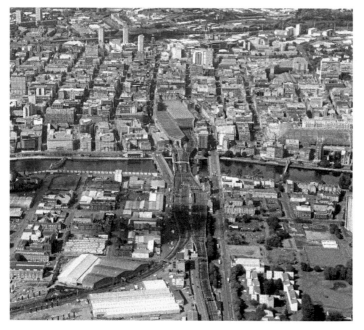

An aerial view of
Glasgow Central
Station.

Right: One of the wrought iron gates at the Gordon Street entrance to the station.

Above: A closer view of the detail on the gate.

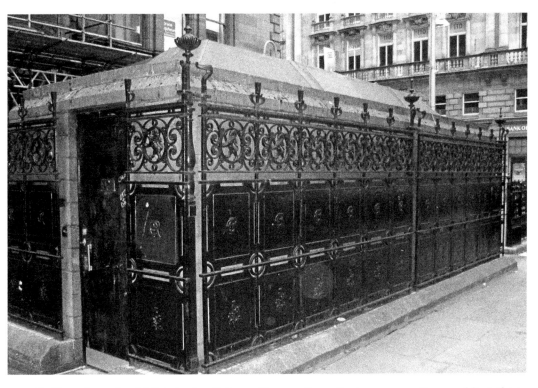

Railings from the old Caledonian Railway Glasgow Cross Station surrounding a public toilet in St Vincent Place.

CALEDONIAN RAILWAY.
TOURS IN SCOTLAND.

THE CALEDONIAN RAILWAY COMPANY have arranged a system of TOURS—over 100 in number—by Rail, Steamer, and Coach, comprehending almost every place of interest either for scenery or historical associations throughout Scotland, including—

EDINBURGH, GLASGOW, ABERDEEN, DUNDEE, INVERNESS, GREENOCK, PAISLEY, DUMFRIES, PEEBLES, STIRLING, PERTH, CRIEFF, DUNKELD, OBAN, INVERARAY,

The Trosachs, Loch Katrine, Loch Lomond, Loch Eck, Loch Earn, Loch Tay, Loch Awe, Caledonian Canal, Glencoe, Iona, Staffa, Skye, Balmoral, Braemar, Arran, Bute, The Firth of Clyde, The Falls of Clyde, &c., &c.

☞ TOURISTS are recommended to procure a copy of the Caledonian Railway Company's "Tourist Guide," which can be had at any of the Company's Stations, and also at the chief Stations on the London and North-Western Railway, and which contains descriptive notices of the Districts embraced in the Tours, Maps, Plans, Bird's-eye View, &c.

Tickets for these Tours are issued at the Company's Booking Offices at all the large Stations.
The Tourist Season generally extends from June to September inclusive.

The Caledonian Co. also issue Tourist Tickets to The Lake District of England, The Isle of Man, Connemara, The Lakes of Killarney, &c.

The Caledonian Railway, in conjunction with the London and North-Western Railway, forms what is known as the

WEST COAST ROUTE
BETWEEN
SCOTLAND AND ENGLAND.
DIRECT TRAINS RUN FROM AND TO

Glasgow, Edinburgh, Greenock, Paisley, Stirling, Oban, Perth, Dundee, Aberdeen, Inverness, and other places in Scotland,
TO AND FROM
London (Euston), Birmingham, Liverpool, Manchester, Leeds, Bradford, and other places in England.
Sleeping and Day Saloon Carriages. Through Guards and Conductors.

The Caledonian Company's Trains from and to Edinburgh, Glasgow, Carlisle, &c., connect on the Clyde with the "Columba," "Iona," "Lord of the Isles," "Ivanhoe," "Gael," and other Steamers to and from Dunoon, Innellan, Rothesay, Largs, Millport, the Kyles of Bute, Arran, Campbeltown, Ardrishaig, Inveraray, Loch-Goil, Loch-Long, &c.

A full service of Trains is also run from and to Glasgow, to and from Edinburgh, Stirling, Oban, Perth, Dundee, Aberdeen and the North, and from and to Edinburgh, to and from these places.

For particulars of Trains, Fares, &c., see the Caledonian Railway Company's Time Tables.

The Caledonian Company's Large and Magnificent
NEW CENTRAL STATION HOTEL, GLASGOW,
is now open, under the Company's own Management.

GENERAL MANAGER'S OFFICE,
GLASGOW, 1884.

JAMES THOMPSON,
GENERAL MANAGER.

Caledonian Railway Tours in Scotland.

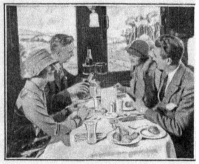

Scotland by LMS

The West Coast Route from Euston
The Midland Route from St. Pancras

TAKE your ticket to Scotland by the London Midland and Scottish Railway via Carlisle and you can travel by either of the two most interesting and beautiful routes to Scotland. Better still, you can go by one and return by the other. The LMS is the only Railway affording this facility.

The LMS is famous for comfortable travel. It has always carried the heaviest traffic to Scotland. Track, road-bed, rolling stock and control are all maintained at the highest level. Restaurant cars by day and sleeping cars by night accompany fast trains to Scotland.

Full Passenger Services are now running.

STAY AT LMS HOTELS
at Glasgow, Edinburgh, Turnberry, Gleneagles, Dornoch, Strathpeffer, Inverness

Particulars from any LMS station or town office or from the LMS Divisional Passenger Commercial Superintendents at Euston; Manchester, Hunt's Bank; Birmingham, New St.; Glasgow, Central Station.

LMS
LONDON MIDLAND AND SCOTTISH RAILWAY

Scotland by LMS.

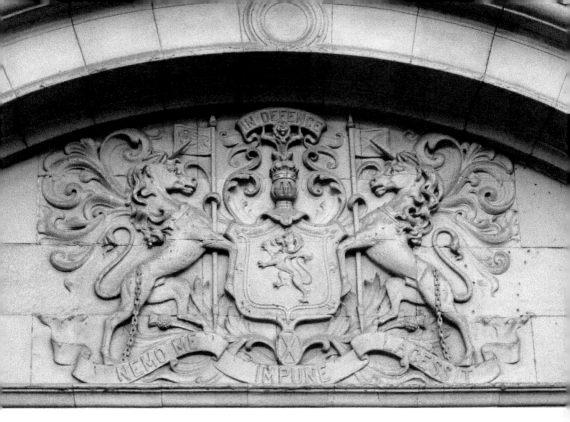

Caledonian Badge.

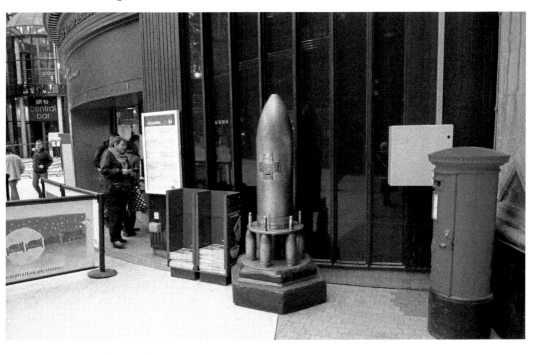

Meet you at the shell.

Acknowledgements

In completing this book, I have been able to draw on the goodwill of many railway and architectural enthusiasts and I am very grateful to them for allowing me to use their images and for preserving Glasgow culture.

I am particularly indebted to Mr R. M. Casserley for a range of wonderful black and white images from 1946 to the 1950s; also to Kashif Rashid and John Menzies plc for images of their shops in Glasgow Central Station, Stirling and Carlisle; to Stewart Macartney and Blyth and Blyth for their support and use of their wonderful images; to Harjeet Kaur Sandher and Principal Hayley Hotels for images of the Grand Central Hotel, Glasgow; to James Reid, Lime Merchants - Howie Minerals, part of the Leith's Group of companies; to Robert Pool for the use of images and adverts from his Glasgow Collection; also to Elaine MacGillivray and the Mitchell Library for use of images.

Other images from Barrie Watkins, Dag Nilsen, Andrew Lynch, Thomas S. Cook, Michael Patterson, Tony Smith, Paul Masson, Keith Long, Bruce McCartney, Adrian Nicholls, Azam Khan, A. G. C. Thoms and Toddish McWong.

I have also used Wikimedia Images from Dave Croker - Inside Central Station; Green Lane - Concourse of Central Station; Ben Brooksbank - Refurbished DMU; Kim Traynor - Marks and Spencer's; ArtVandelay - Class 318 at Glasgow Central; Geoff Sheppard - Siemens Desiro.